Postcard History Series

Kane County
in Vintage Postcards

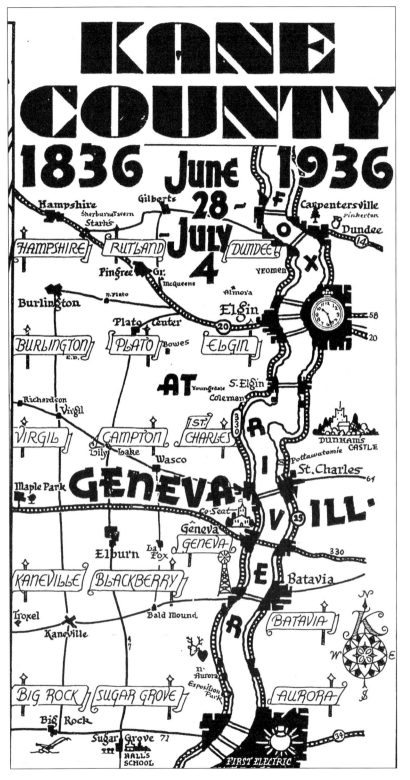

"Not only do the people of this county represent the true ideals of the nation, but they are destined to remain, as they are and have been, one of the banner sections of the state and nation, where dwell and shall continue to dwell an intelligent, law-abiding, up-to-date population now numbering more than 250,000 people and destined before the coming of another centennial year to provide homes and occupations for many times that number," wrote R. Waite Josyln, historian, in 1936.

POSTCARD HISTORY SERIES

Kane County
IN VINTAGE POSTCARDS

Jim and Wynette Edwards

Copyright © 2001 by Jim and Wynette Edwards.
ISBN 0-7385-1866-2

Published by Arcadia Publishing,
an imprint of Tempus Publishing, Inc.
3047 N. Lincoln Ave., Suite 410
Chicago, IL 60657

Printed in Great Britain.

Library of Congress Catalog Card Number: 2001088705

For all general information contact Arcadia Publishing at:
Telephone 843-853-2070
Fax 843-853-0044
E-Mail sales@arcadiapublishing.com

For customer service and orders:
Toll-Free 1-888-313-2665

Visit us on the internet at http://www.arcadiapublishing.com

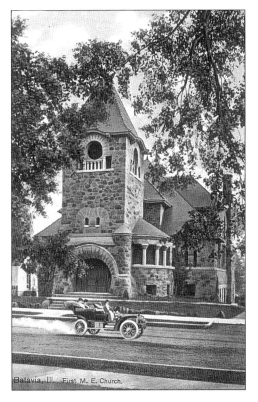

A sporty touring car speeds past Batavia's landmark Methodist Episcopal Church. Its construction was funded by two of the town's leading citizens, Captain Don Carlos Newton and Elijah H. Gammon, a Methodist minister. The church is of Romanesque Revival style, modeled after a church in France.

Contents

Acknowledgments		6
Introduction		7
1.	Postcards and the History of America	9
2.	Kane County: Land of Hope and Glory	15
3.	Aurora, Montgomery, Sugar Grove, Big Rock, Troxel	25
4.	Batavia, Geneva, Mooseheart, North Aurora, Kaneville, La Fox	49
5.	St. Charles, Lily Lake, Elburn, Virgil, Wayne, Wasco Maple Park	69
6.	Elgin, South Elgin, Plato Center, Burlington	89
7.	Dundee, Carpentersville, Hampshire, Starks Gilberts, Pingree Grove	111
Index		126

ACKNOWLEDGMENTS

For decades, people researching the early history of Kane County have referred to the seminal work written by R. Waite Joslyn a hundred years ago. Joslyn was an early "modern" researcher who included extensive primary sources and social history in his study of Kane County. His writing is colorful and full of interesting "Believe It Or Not's," along with the customary facts, dates, places, and important people. This book, *Kane County in Vintage Postcards*, is dedicated to his memory.

The area historical repositories have helped greatly in putting this book together by kindly loaning out postcards from their collections—the Aurora Historical Society (1), the Big Rock Historical Society, the Dundee Township Historical Society, the Elgin Area Historical Society, the Geneva History Center (2), the St. Charles History Center, and the South Elgin Heritage Commission.

Postcard collectors are a lively and friendly lot, willing to share their "treasures" with others. Many cards in this book have come from the private collections of Len Duszlak, Eloise Rice, Charlotte Wood, Jack Wendt, Linda Schultze, Ron Gregorek, Nell Evans, Ronal Wells, Donald Murphy, Dale Hess, Shari and Paul Motylinski, and Joe Behn.

Several people have been helpful with local histories and to the following individuals, we are grateful: Neil Ormond, Ruth Frantz, Jack Wendt, Louise Judd, Becky Byington, Donald Murphy, Ronald Wells, Claudia Thermain, Anne Reines, Violet Busby, Kay Dillard, and the librarians at the Aurora, Batavia, and Ella Johnson Memorial Public Libraries. In several cases, when old postcards could not be found, the authors photographed views in order to include more of the villages in Kane County.

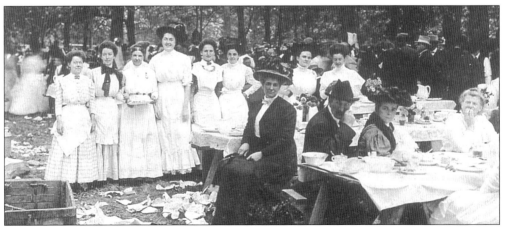

(Cover) The "Dining Hall" at the 1909 Big Rock Plowing Match held at Long's Woods. Right to Left: Tillie Evans holding her infant Merritt, Levi Evans, Fannie Evans, Orva Jones, Clara Haley, Della Williams, and Gladys Butcher.

INTRODUCTION

Kane County in Vintage Postcards tells the story of the beginning of Kane County through its first 100 years, 1838 through 1938, featuring postcards of that period. It is not intended to be a definitive history of all that has occurred over that time period, but simply to offer up postcards of Kane County in a pleasing and narrative fashion.

The vast majority of the 375 postcards screened for selection in this book were from the cities of the Fox Valley. However, the postcards from smaller farming communities in the western area of the county were treated with great respect, for they focus on the lifeblood of the growing urban centers to the east.

Kane County has never been more successful than it is today, entering a new century. Some see danger in its population and industrial growth. As more and more good farmland is sold off for the shopping centers and tract housing appears alongside old abandoned farm sites, Kane County runs the risk of a great change in its nature and character. Others see this change as a natural and continuing one. Immigrants still flock to Kane County for jobs and opportunities for a rich life for their families, just as the Yankees, Germans, Scandinavians, British, and French did so long ago.

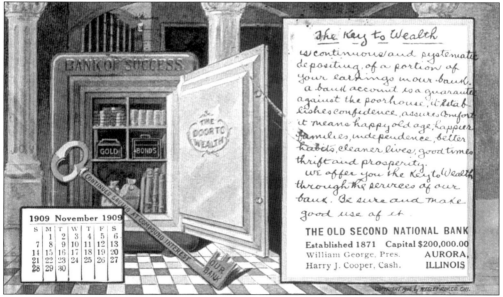

Postcards were beginning to serve as a mass advertising device by 1909. This view not only promotes the Old Second National Bank in Aurora and encourages the public to place their money with them, but it also offers advice as to what was "The Key to Wealth." The card serves as a handy calendar for November to find its way onto the desk of the potential customer.

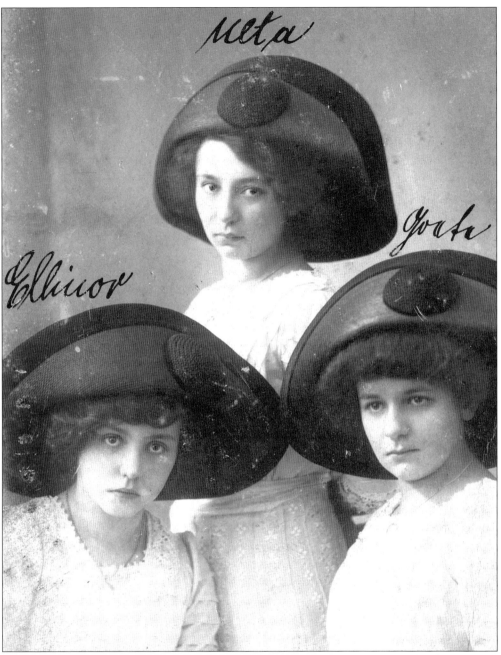

Pictured above are three Kane County Femme Fatales of the 1890s. Thousands of Americans who collect postcards would be surprised to know that today they are labeled "historians," but the label is a fitting one. They are helping to preserve important images from America's past, and their collections are forming the basis for countless interesting books depicting the passing American scene. The production of new postcards has made it into the 21st century, but people no longer use the postcard as a major means of communication. It is a pity, but we do have the glorious and fascinating postcards of the past to tell their never-to-be-forgotten stories of a great nation's people. (1)

One

Postcards and the History of America

There was a time when American history books concentrated only on telling the sanitized story of all the great men and political events of our nation's past. This approach, a litany of "facts, dates, and places" ignored the economic and social dimensions of the story of America. Rarely was controversy dealt with in these early history books, and the role of women and minorities was usually carefully swept under the carpet. Writers of these histories were not concerned with those things. For their generation, history was just something to be used to manipulate the next generation and to make them "good little Americans" who would question nothing. Rarely did those books use such words as "perhaps" or ask people to use higher thinking skills with the simple word "why?"

Today, all of this has changed. A typical high school American History textbook is just as likely to include an experience of a young girl working in a New England textile mill as it is to present a statistical analysis of presidential electoral results. Texts now include pictures of everyday items of the past and note what they tell us about the people who wore them, sang them, or used them. It is not unusual to find history books today that include mini-studies of cartoons, songs, architecture, and many other exciting ways to look at the past. This type of historical inquiry has come to be called pop(ular) history. Recreating the past is like trying to assemble the pieces of a vast puzzle. Looking at the past in various ways helps us come to a more accurate and balanced look at "the good old days." Any artifact produced in America is very much a part of solving the puzzle of the past.

A study of postcards helps us to reach out, touch the past, and fill in some blanks in the puzzle. Postcards were found here and in Europe prior to the American Civil War, but four key elements made them popular pictorial message senders of the last part of the 19th century and the first part of the 20th. First, cheap and effective transportation made it possible to send cards to all points in the United States, and secondly, the invention of the lithographic printing press made it possible to print cards for a fraction of a penny. In some cases, a person living in one city could send a postcard in the morning to a friend in a nearby city announcing an upcoming visit that same evening. Twice daily, home delivery of mail was maintained in this country until after World War II.

The third element involved Kodak and his cheap, every-man camera produced at the turn of the 20th century, which turned thousands of Americans into camera buffs who could not only record their own experiences on film but could also send them out as postcards. This ability of ordinary people to make, send, and receive images is still part of one of the most talked about and argued American characteristics—rugged individualism and independence. We want to do it ourselves! Witness today the thousands of computers transmitting digital images of babies and photographs of the latest vacation hot spots.

The fourth component that made postcards a mass media success was the gasoline engine. With inexpensive cars and motorcycles, paved motorways, and gas stations, America hit the road, thereby changing the face of the country forever. Motels and tourist attractions covered the land like the plague. Along the way, motorists stopped to mail postcards of their marvelous "finds" and scribbled the mantra of the day, "Having a wonderful time, wish you were here!"

When the postcard was in its Golden Age, one could buy them at practically every retail location in every village in America. A whole new industry was created. Hundreds of makers of cards dotted the land. Americans sent cards announcing their arrivals, departures, holidays, and patriotism. On another level, they also chronicled the story of America by recording the country's most popular things and most intimate feelings—such as love, grief, and humor.

Photographic calling cards, advertising cards, and many types of trading cards became popular in the later part of the Victorian era. Billions of "cards" rolled off the presses during this time. The Victorians were in love with colors—the brighter the better. The most popular cards of the day were chromo (color) lithographs. Soon newspapers and magazines joined the craze to color. (1)

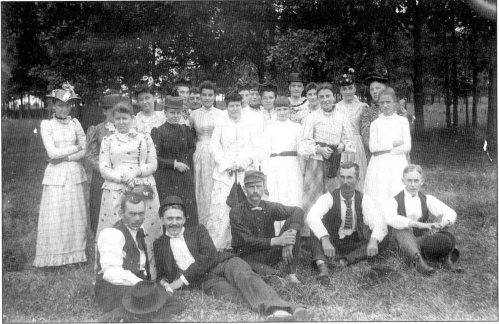

From an historical social sense, among the most interesting postcards today were the ones made by amateur photographers who told the story of America one family at a time. These rare postcards form part of the valuable historical material on the local level.

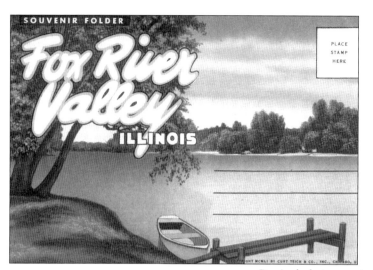

After the Civil War, there were hundreds of small companies producing postcards, but there were a few giants of the industry, such as Curt Teich in Chicago. Teich, one of the oldest card printing companies in the United States, became the world's largest volume printer, printing 250 million cards a year at its peak! Teich produced dozens of postcards of Kane County scenes.

Particularly interesting are the photo folders with multiple cards folded together, such as this "Fox River Valley, Illinois."

Other companies in the Midwest who produced postcards included E.C. Kropp in Milwaukee, the Detroit Publishing Company, C.R. Childs Company of Chicago (specializing in views of Chicago's neighborhoods and suburbs), and Morrisson Plummer of Chicago (specializing in embossed holiday cards such as this flower Easter greeting card).

Plummer's Easter cards, of which the company had 36 designs at the time of this card, sold for $4 per thousand or 6¢ apiece if you only ordered 100. They also carried silk plush, papier-mâché, and gold-embossed Easter cards.

Postcards were made of many different materials. Some cards were made of woven silk, and others were printed on leather. One company produced cards with copper "windows" that shimmered in the light. Felt was pasted onto cards, glitter was used, and many holiday cards were embossed.

The vast majority of cards were a standardized 3.5-by-5.5 inches, but the post office in the United States allowed smaller and larger cards to go through the mail. The manner of printing varied over the years. Postcard types include color lithography, collotype, photoprint, halftone (color or black and white), photoengraving, and colored collotype. Some early cards were hand water-colored.

Postcards today are regarded as an original art form. Humor cards were big sellers, and while some of the humor of yesteryear is not exactly considered funny nowadays, some cards are still contemporary in their humor. Cheating husbands and courting couples "spoonin" were some of the most popular themes.

Cards featuring works of art by famous sculptors and painters were popular sellers, even as they are today. The Art Institute of Chicago has dozens of postcards featuring their most popular works of art. Among the most valuable old cards are those produced by the French Art Nouveau artist, Mucha, who created art for cards featuring the department store Belle Jardinieve and Waverley Cycle. One of his postcards from 1898 sold for $13,500 in 1990!

Two
Kane County
Land of Hope and Glory

"(Kane County)... is a piece of land thirty miles long and eighteen miles wide, within whose borders dwells... people of many different nationalities; a people whose products are distributed to the four corners of the civilized world. Today it is the home and workshop of a prosperous population," wrote R. Waite Joslyn and Frank W. Joslyn almost a hundred years ago. What the Joslyns saw in 1908 is still an accurate description of the land and its people in the year 2001. The land is still rich in natural resources, and its people remain, as in the past, the greatest resource of Kane County. From the small towns and villages of the county to the bustle of the large population centers of Elgin and Aurora, Kane County remains anchored to the best of rural and urban life.

When Illinois lands became public domain following the Land Ordinance of 1787, a few settlers began to arrive in central and southern Illinois. By 1818, these frontier people of English, German, and French heritage numbered over 60,000, and the great state of Illinois came into existence. After the Blackhawk Wars ended, settlers migrated into northern Illinois and Kane County.

The earlier pioneers who came to Kane County were of the same stock that had built a great nation out east, those who had created a nation out of chaos and had pushed westward seeking good lands on which to grow crops and raise children. Many of them were of Scottish, Irish, English, Pennsylvania Dutch, and French Huguenot heritage. Christopher Payne was the first to arrive from New York. The McCarty brothers of Aurora were of Scot and English stock, and founders of many other villages came from New York. A great number of Kane County's earliest homesteaders were from Congregational churches back east. They soon had established some of the first churches in each township and village.

When the first wave of Kane County settlers arrived in the mid-1830s, Andrew Jackson had won the White House for another four years, and the center of population for the country was near the western edge of Maryland. America was still an agrarian, rural country with only ten percent of its population living in cities.

Technology has always been a major driving force in Kane County. From the windmill factories up and down the valley in the late 1800s, to today's cutting-edge research at FermiLab in Batavia, the manufacturers have supplied jobs and prosperity to the valley over the years. Unfortunately, the various farming operations in the county are at risk today to the urban sprawl, which threatened to place rows of houses instead of rows of corn on the rich soil of the land. Hopefully, a balance can be maintained, and Kane County can continue to enjoy the diversity of mass production of goods and services, as well as mass production of farm commodities.

The land that was to be Kane County was first filled with various Native Americans—the Fox, Sac, Illinoa, and the Pottawottamie—before white settlers came. In 1832, Blackhawk, a Sac diplomat and leader, led a rebellion for Native American lands east of the Mississippi. Federal troops marched across the county, south of Elgin and through parts of Plato Township, in pursuit of their adversaries. The Native Americans did not succeed, and their last villages located near Dundee, Batavia, and Aurora were moved west.

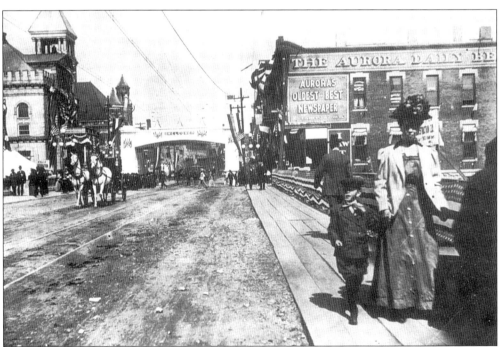

Church meetings and newspaper presses soon followed the construction of cabins. Rev. John Thomas in St. Charles published the first newspapers in the county, *The St. Charles Patriot* and the *Fox River Advocate*, in 1842. In 1848, Rev. Rounseville in Aurora started *The People's Platform* newspaper as a Democratic party sheet. By 1909, the dominant paper in Aurora was the *Aurora Daily Beacon News*. This view shows its building with a huge outdoor advertisement.

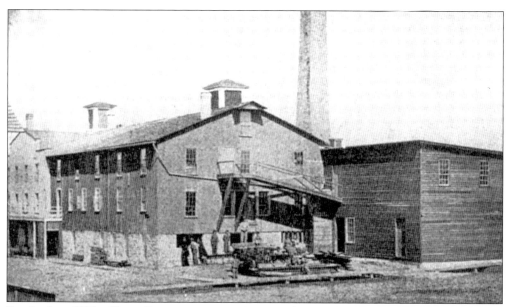

By the late 1830s, Kane County was attracting "Yankee" and "Hoosier" settlers from New England and Indiana. Many of the farmers kept cattle and sold both milk and cheese. Eventually, production of milk and cheese was so large that regular milk trains left towns such as Elgin and St. Charles each day to meet Chicago's growing demand for dairy products.

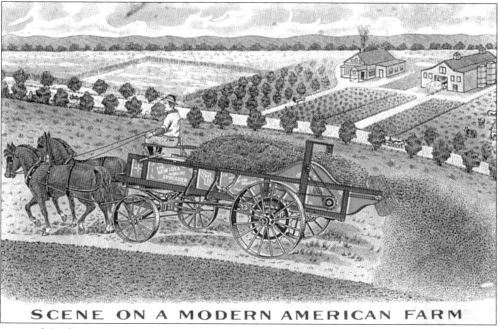

SCENE ON A MODERN AMERICAN FARM

Most of the first immigrants to Kane County were farmers. River power was available to drive mills and to operate early factories, The brisk winds of the prairie provided wind power for both farm and factory. Soon, small factories throughout the valley were producing new farm implements and wagons to meet the needs of farmers. Land was so cheap that few people wanted to work for others when they could work for themselves!

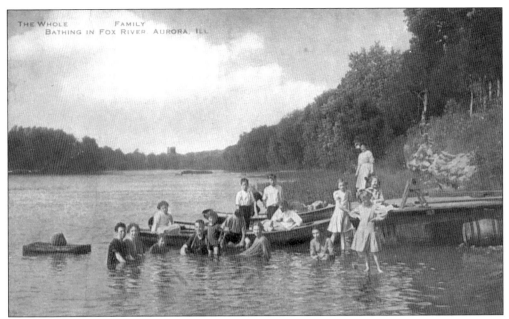

This postcard depicts a group of bathers in the Fox River. Notice the exposed rocks on the bank of the river. Also found along the riverbanks were rock, sand, and clay. Surface rock underlying Kane County belongs to the Silurian formation, mostly of the Niagra group commonly called limestone. This stone was quarried in several Fox River towns.

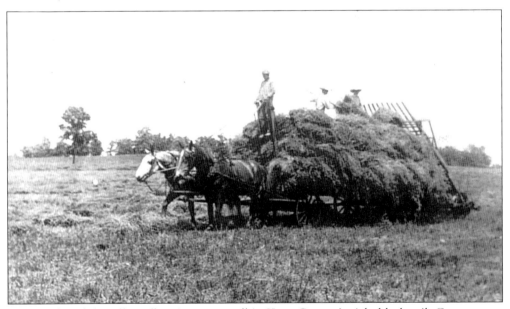

Farmers found that all small grains grew well in Kane County's rich, black soil. Corn was an early success and became the staple crop of the county. During the Civil War, farmers took advantage of the increased war time needs of the Union and established dairy operations. Soon there were dairy "factories" in Elgin, St. Charles, Sugar Grove, and Batavia that took advantage of the railroad lines which passed through their towns and took the dairy products to market.

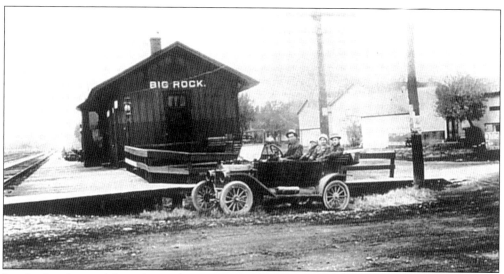

Land prices jumped from 25¢ to $1.25 per acre in Kane County in the 1830s, to $90–$125 per acre by 1900. The typical farmer in the 1840s was from New England. The next largest group of farmers were German or Scandinavian immigrants. In 1900, the Josylns wrote that "Germans and Scandinavians accumulate property by frugality and toil while the native Yankee would not make ends meet." Towns such as Big Rock sprang up around rail stations when the railroads ran west through the county.

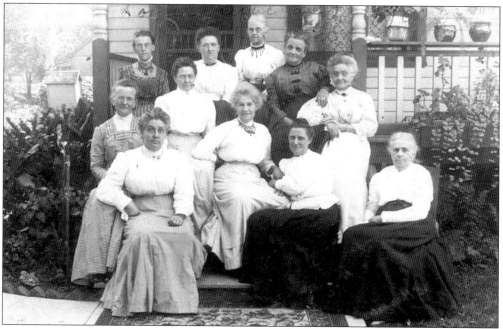

Life for pioneer farmers in the 1800s was difficult, and the women often worked along with the men. The Baker family came from England and settled in Virgil in 1851; the Balduc family came from Quebec and settled in Aurora in 1867; and the town of Plato Center claimed the Fitchie family, who came from Germany in 1895. This postcard of Kane County women *c.* 1895 shows a proud group of women who helped tame the land. (1)

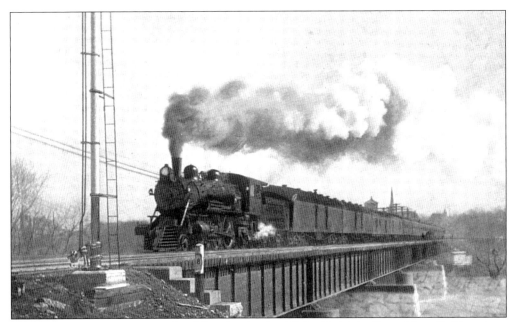

A Kane County visitor wrote the following in the 1850s: "I think after taking all things into consideration, that I may safely proclaim it the best county in the State. Although the prairie land predominates, it is interspersed with valuable groves, containing timber sufficient for fuel, fencing and building for years to come. Railroads pass directly through it and affords a ready communication at all times with Chicago. . . its magnificent river, which supplies so much water power and propels so much machinery, adds materially to the wealth and business of the county."

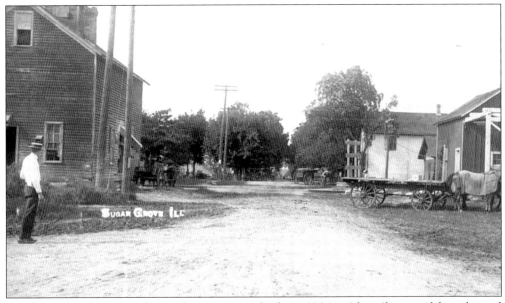

Sugar Grove's first log cabin and tavern were built in 1836, with nails, sawed boards, and shingle roofs. The post office was built in 1840, and P.Y. Bliss built the first store in 1839. His store was one of the largest in Kane County, drawing customers from miles away. (1)

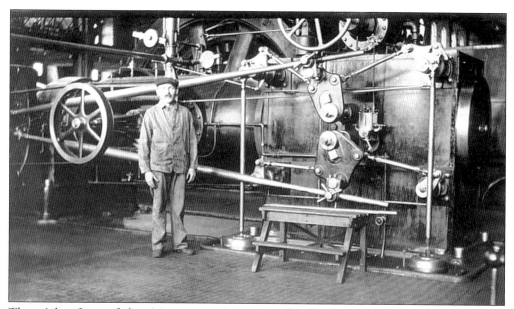

The mighty force of electricity was used to power the newly completed Chicago, Aurora, & Elgin Electric Railroad, which was built to bring visitors to Kane County and to offer a quick commute (about an hour) to Chicago in 1902. The powerhouse, built in Batavia and shown on this view card, had four generators and eight boilers, which used 5 million gallons of water each day to create electricity that powered the third rail system.

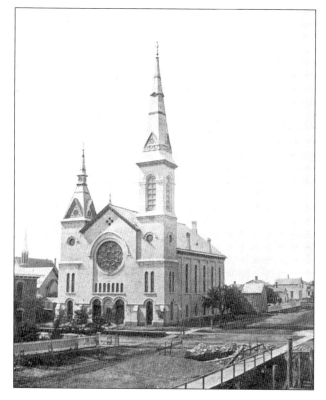

Elgin, like Aurora, its industrial sister city to the south, was home to dozens of churches by 1908. There were 34 churches and 5 missions in the city at that time. An early visitor to Elgin, population 2,000, said, "(Elgin) is a church town and Christian. The scarcity of grog-shops proclaim as unequivocally that here King Alcohol is not an absolute monarch."

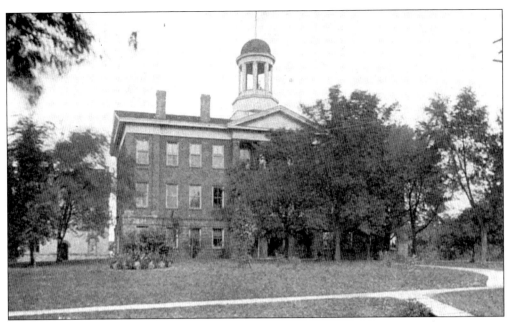

The State of Illinois granted the original charter for the Elgin Academy in 1839, but it was not until December of 1856 that it was opened to students, and only in the 1870s did the school begin to grow. Its lifelong theme songs states, "On the banks of the old River Fox, my boys, the academy ever more shall stand." The school is still standing today.

Aurora, the major industrial city of southern Kane County, claims to be the first city to have electric streetlights. From 1881 to 1886, a private company provided 16 towers 160 feet high, with lights of 2,000 candlepower. Then the city built its own municipal system to put the light on 15-to-20-foot towers at street intersections. Later, streetlights in town were mounted on Art Nouveau, curvy, street posts closer to the streets, as shown above.

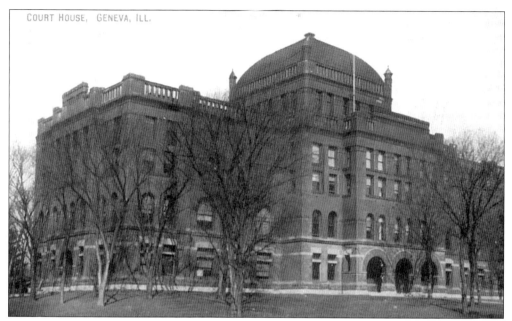

Kane County's fifth courthouse, located in downtown Geneva, is shown on this postcard. It served for most of the past century and continues to hold offices of the court. This building's dark, red stone exterior and Romanesque architecture is striking. Kane County's fourth courthouse was just as architecturally interesting. It was a Gothic structure with a belfry-like tower surrounded by a grove of trees.

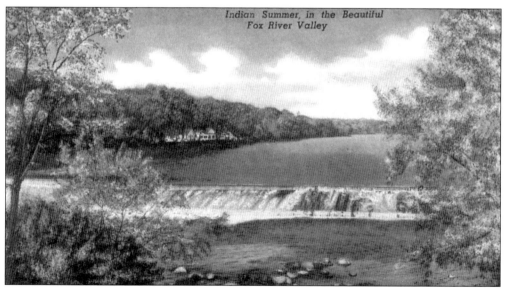

A letter written in 1851 describes the beautiful and graceful Fox River. "The river which rises a few miles northwest of Milwaukee and flows so tardily to the state line, and then through McHenry County, Illinois, begins, as it approaches the line of Kane County, to move more rapidly. It passes in early a straight course from north to south through the eastern part of the county. . . dotted by well cultivated farms presents an appearance which beauty's self might envy."

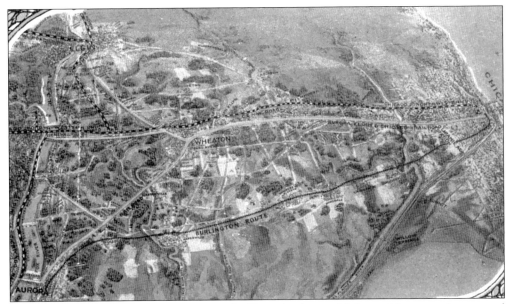

Kane County has one of the most unusual villages in the world, located between Aurora and Batavia. The Supreme Lodge of the World, Loyal Order of the Moose, governs Mooseheart. It was established as a home for dependent children of deceased members of the order. Residents are housed and educated on the premises. This air view postcard shows how easy it was to reach Mooseheart from Chicago.

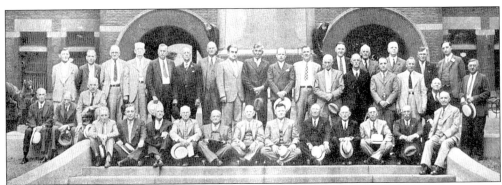

From June 28 through July 4, 1936, Kane County celebrated its centennial with a week of special events, including an original pageant about the early days of the county. This 1936 board of supervisors gathered on the courthouse steps to pose for this commemorative photo.

Three

Aurora, Montgomery, Sugar Grove, Big Rock, Troxel

Aurora is located in the southeast corner of Kane County. Before the arrival of white settlers, Winnebagos, Sacs, Fox, Pottawatomies, and other tribes spent their summer months near what is now Aurora along the Fox River. Joseph McCarty, a millwright from New York, is said to be the first white settler in Aurora. He and his brother "squatted" on 360 acres of land on the east side of the Fox, and started a saw mill. By 1835, word had spread to all parts of New England about the opportunities in Aurora. Theodore Lake laid out the village of West Aurora in 1842, and had the first store in town. In 1857, West and East Aurora agreed to put aside their rivalry and form one city. By the end of the century, Aurora boasted of various state-of-the-art businesses, such as the immense C B & Q rail yards. As if all of this was not enough, Aurora's factories produced enough silverware, corsets, road equipment, art, wagons, well works, railroad engines, cards, stoves, woolen goods, hardware, doors, bricks, drain tile, and butter to satisfy local, state, and national customers. The 1920s were part of a boom time in Aurora, and new prairie-style commercial buildings were constructed downtown .

Montgomery is adjacent to Aurora and is located south on the Fox River. Elijah Pierce is credited as its first settler in 1834. His one-room shanty of a house became a stagecoach station, busy tavern, and boarding house. Daniel Gray brought his family to settle in 1836. The town was known as Graytown, but he later changed the name to Montgomery. The village had a gristmill in the 1850s, which was later used to grind mica. The Burlington Railroad built pens for 75,000 sheep in Montgomery around 1890. Montgomery was also home to one of Chicagoland's greatest amusement parks in the early decades of the 1900s.

People from Wood County, Ohio, settled Sugar Grove, west of Aurora, in 1834. Religion and liquor came to town early. A tavern was opened in 1836, and two years later the first religious services were held in a small frame house. A post office was established in the home of Thomas Slater by 1840. Farmers organized a library of 264 books in 1843. Schools were built, and a city hall was completed in the 1850s. The dairy business was a major industry by the end of the Civil War. In 1866, a cheese factory contributed to a bustling local economy. The Chicago and Ohio Railroad first served both Sugar Grove and the township, but by the turn of the century, the tracks belonged to the C B & Q Railroad.

Farmers from England, Ireland, and particularly from Wales settled Big Rock in the 1830s. Around 1840, a stage coach road was constructed from Chicago to Galena, through Big Rock. The name of Big Rock was chosen for the village after the township—which had been named by the Indians after a rock in the local creek. In 1860, the land baron of Big Rock was Joshua Rhodes, who owned the very land that the village was built upon. In 1871, the C B & Q Railroad came through town, and the station was named Blunt Station. Agricultural goods were shipped out from here. In the 1870s, Big Rock had a wagon shop, a steam feed mill, and a large grain elevator. A fire destroyed almost all of the downtown in 1890. The next decade saw the construction of the

First Baptist Church and the English Congregational United Church of Christ.

Troxel is a very small community located at the crossing of County Line Road and Owens Road, 6 miles south of Maple Park. The land that became Troxel in 1905 originally belonged to J. Shoop and J. Morse in the 1860s. Today, Troxel has a total of 8 houses, 2 of which are on farms.

In the years before World War II, there were about 475 different cars being produced in Illinois. Aurora also entered into the business of car making. The Thor Company built the "Aurora" and the "Thor" motor cars in 1906, neither of which were produced in vast numbers. The Thomas Dunham Co. in Aurora began by manufacturing automotive accessories and eventually sporty bodies that converted Model T Fords into racy-looking automobiles. One of their models was called the "Newport Speedster."

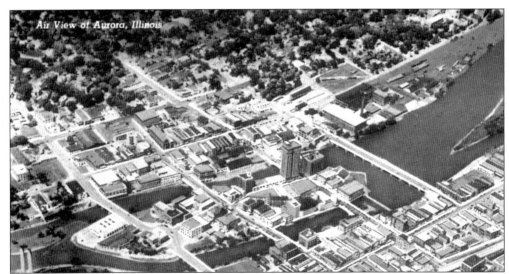

Much of the early manufacturing in Aurora took place on the banks of the Fox River and on the island between East and West Aurora. J.D. Stolp started a wool carding operation on the island in 1837, which became known as Eagle Mills in 1849, when Stolp opened a woolen mill on Mill Street. The first major buildings on the island included two hotels, a library, city hall, the post office, an entertainment complex, and after the Civil War, a G.A.R. Memorial building.

Many postcard companies issued cards for sale in Aurora. Peterson of Aurora and Paul R. Vogel of Chicago were just two of these companies. The souvenir folder (measuring 3-by-4 inches) offered 16 turn-of-the-century views. It was published by Vogel but printed by Teich and Company in Chicago. Some early Aurora postcards were even printed by Raphael Tuck & Sons of England, who were art publishers to the royal family.(1)

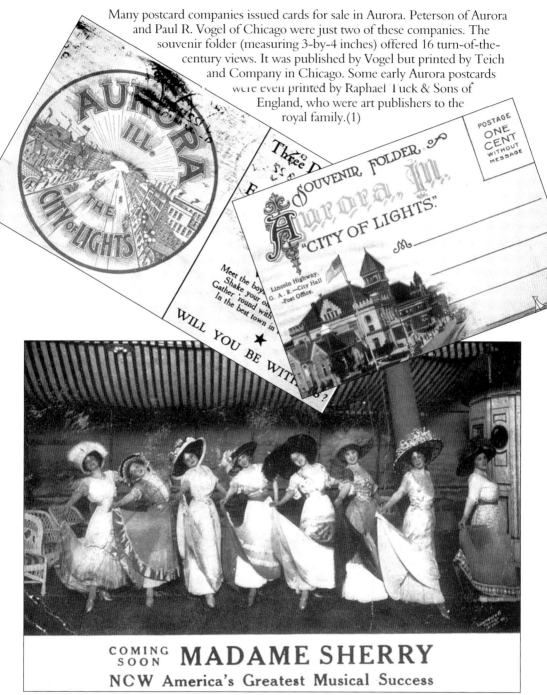

In the years just before Word War I, Aurora had many entertainment houses to choose from. In addition to the Aurora Opera House, there was also the Star Theatre on Main Street, and its neighbor theater, the Lyric. The Fox, the Palace, the Princess, Dreamland, the Majestic, the Aurora, and the B theaters were all located on Broadway. Most of these theaters were combination vaudeville and silent film houses.

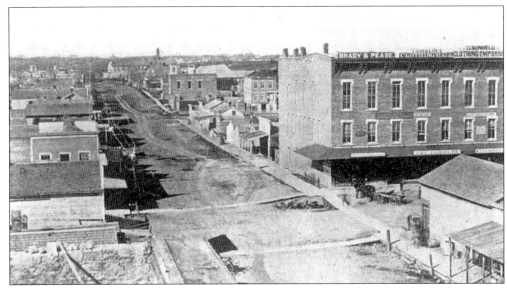

Broadway, which runs north and south on the east bank of the Fox River, was destined to become a major street in downtown Aurora. This 1855 view looking north almost resembles a western frontier scene, with its dirt road, wooden sidewalks, and wooden walk to the other side of the road. A covered wagon is shown in front of the Brady and Pease Clothing Emporium. (1)

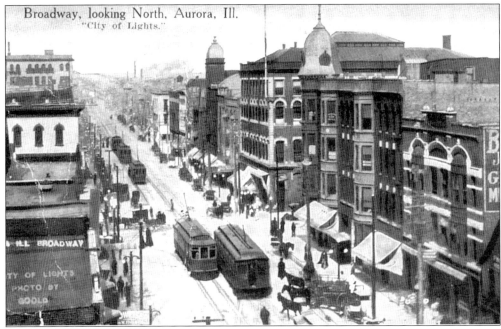

By 1900, North Broadway had changed drastically. One-story, wooden buildings have been replaced with four and five-story, ornate, Victorian, commercial structures, and the street is lined with electric street cars, which received their power from overhead wires. Large picture windows made sidewalk shopping more pleasant. Note the large, overhanging awnings on many of the stores. The railroad works, with the smokestacks, are visible in the distance. (2)

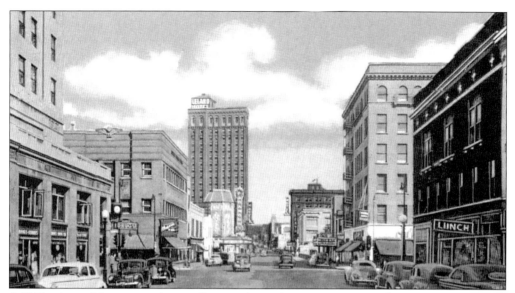

A 1930s view of downtown Aurora features the major east-to-west road in town, Main Street, which is now known as Galena Boulevard. Down the left side of the street is the First American Bank building, a drug store in the old German American Bank building, the Paramount Theatre, and the skyscraper Leland Towers hotel. This landmark building was touted as the tallest building in Illinois outside of Chicago when it was completed.(3)

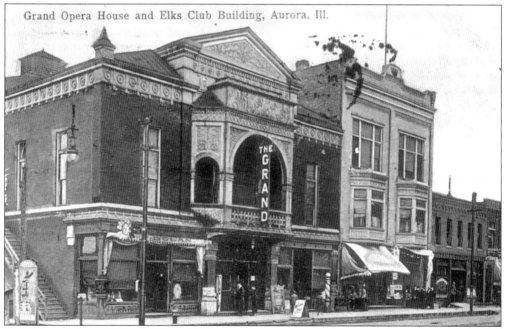

In 1891, politician Colonel Henry H. Evans and a group of others joined together to build the Evan's Grand Opera House. The theater, also called Aurora Opera House, was built on the corner of Broadway and Benton. Over the years, Maude Powell, the Theodore Thomas Orchestra (today known as Chicago Symphony Orchestra), and John Philip Sousa and his band delighted audiences in this theater. It was converted to a silent movie house in 1915. (4)

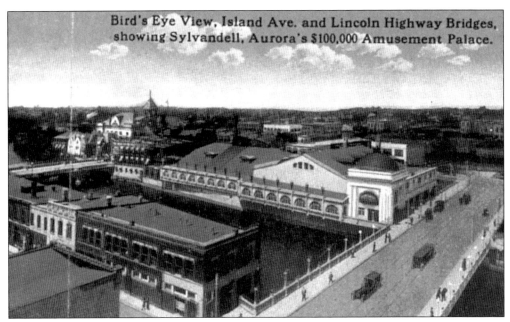

Aurora also had the fabulous Sylvandell Entertainment Palace in its downtown. This view shows the complex at the time when it had been renovated from a dance hall into a 2,250-seat movie and concert house over a basement bowling alley and renamed the Rialto. The complex was heated by steam, as were most of the downtown first floors. The Fox Theatre, another older theater, was behind it.

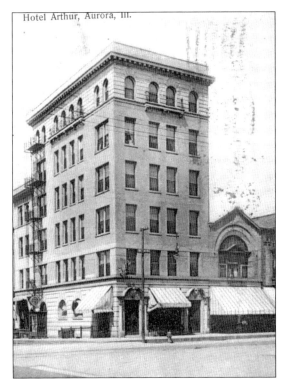

This impressive six-story building at the corner of Broadway and Galena in Aurora still stands. It was the home of the Chicago, Aurora, and Elgin Railroad. Called the Terminal Station, it oversaw a vast rail system that not only serviced Fox Valley towns, but also offered fast, efficient service into its Chicago loop station until 1957. The upper floors were used as a hotel, the Hotel Arthur. (1)

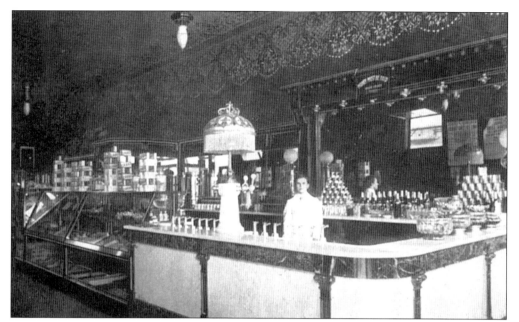

There were several entrances to the first floor in the Terminal Station. There was also a separate entrance to the upper floors, and an elevator serviced the upper floors. The lobby featured an elaborate soda fountain, complete with a marbled counter and fancy soda dispenser. At the counter is N.S. Paulos, who sold other assorted wares such as pastries and cigars to the many travelers. (1)

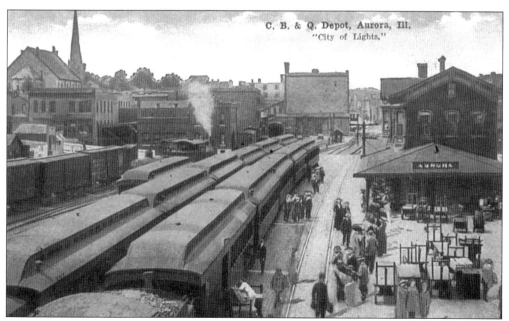

Aurora was a busy railroad center at the turn of the century. The C B & Q Railroad maintained its own station in Aurora, moving passengers in and out of Chicago and downstate to Quincy. The building in front of the engine giving off steam was the F.E. Royston & Company, owned and run by four brothers who sold groceries at 108 Main Street.

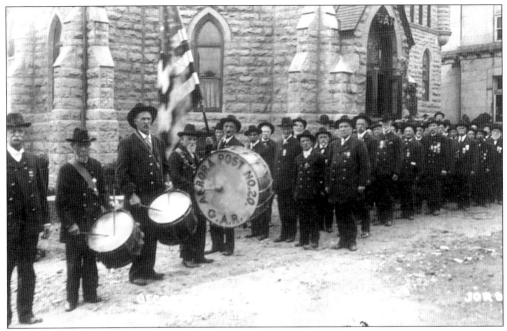

At the conclusion of the Civil War, many communities honored their veterans with marble statues and plaques. The leaders of Aurora decided that a Gothic-style building would be a more fitting tribute for those who gave so much. Shown outside the veteran's hall on Declaration Day, May 1909, is a gathering of the Aurora Post Number 20 G.A.R. soldiers, ready to parade. (1)

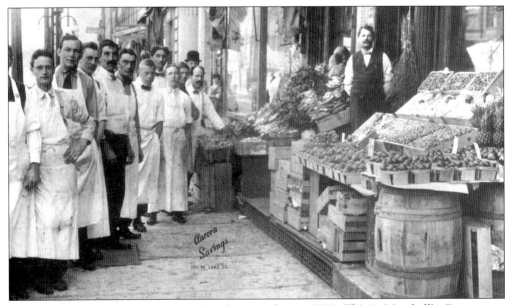

The Art Nouveau streetlight dates this photograph to *c.* 1900. This is Marshall's Grocery on River Street. What a gaggle of green grocers! Notice the pineapples and the wooden cracker box under the street counter with all the other wooden crates. Fox Valley Blue Print is now located on this site.

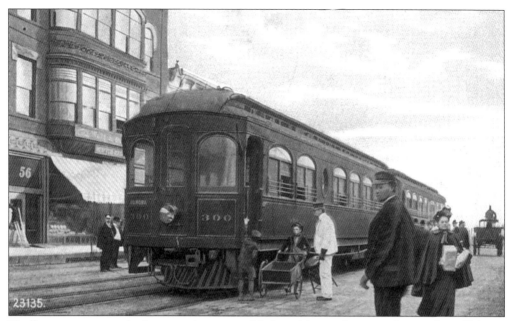

Trolleys gave way to the larger and more sophisticated interurban cars that ran into Chicago at high speeds on a third rail system. The city congestion must have been terrible! Imagine downtown with trolleys, interurbans, horse-drawn carriages and carts, locomotives, and automobiles all fighting for the roadway. By 1922, the locomotives had an elevated track through Aurora.

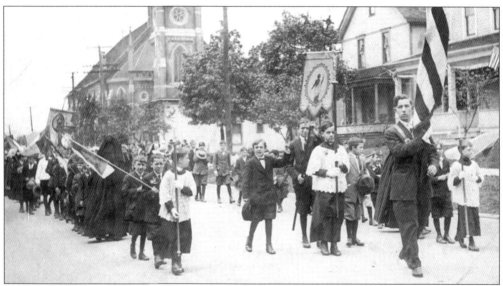

The 1850s saw the arrival of hundreds of Catholics to Aurora, and by 1860, the German Catholics built their own church on two lots at the corner of Liberty and High Streets. They wanted services to be conducted in the German language. The present brick church and school were completed in 1893. This postcard shows an early congregation parading on Liberty Street in celebration of a holy day, delighting in their parochial school, which was saving children from what they called the "godless public schools."

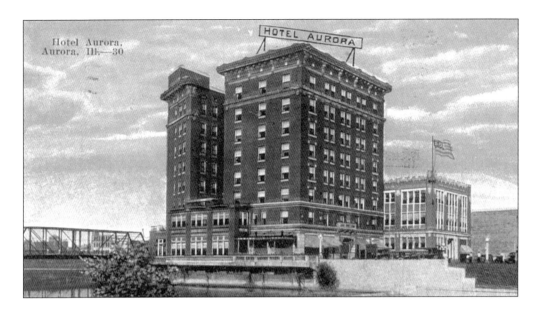

The Aurora Hotel was at one time the tallest building in Aurora. Its 135 rooms and eight stories towered over the downtown landscape. It was designed by the firm of H. Ziegler Dietz and was erected by the Inland Development Company. Deep overhanging metal cornicework concealed panels, behind which colored lights were installed to bathe all four sides of the building. Ornamental ceramic tile medallions decorate the outer wall. The building was abandoned for years, but in the late 1990s, it was restored as apartments for seniors with limited income. The original atmosphere of the lobby area was meticulously restored with its rich, paneled walls using old photographs and this postcard as guides. The hotel is on the corner of Galena and Stolp.

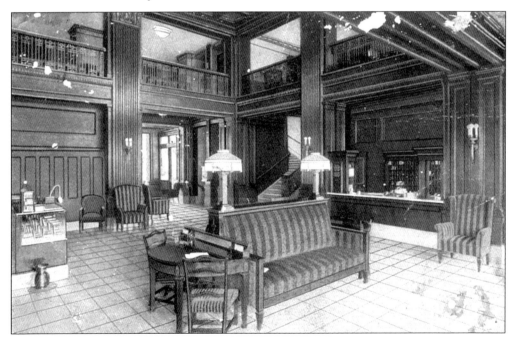

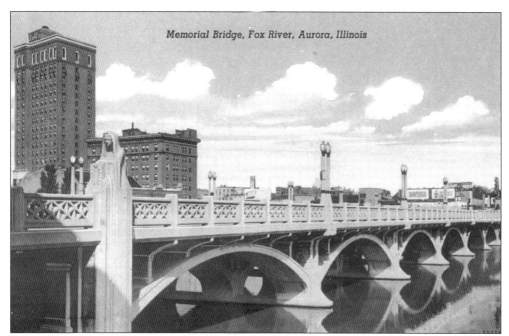

Memorial Bridge, Fox River, Aurora, Illinois

This bridge was built in 1931 to commemorate World War I. It was designed by Emery Seidel, who envisioned the whole bridge as a piece of sculpture. In the center of the bridge, on both sides, are niches with bronze eagles and memorial plaques. In the north niche is a larger-than-life female figure with a wreath called "Victory." On each end of this New York Street bridge are four concrete kneeling women, entitled "Memories."

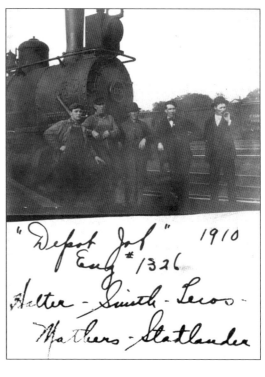

The most treasured and interesting railroad postcards are those informal views taken by amateur photographers. This candid shot, taken in 1910, is of the hearty crew of Engine #1326, which operated out of the Aurora rail yards. Standing in front of their engine are, from left to right: Norves Holter, Smith, Lecos, Mathes, and Statlander. Notice the CB&Q rail car in the background. (1)

35

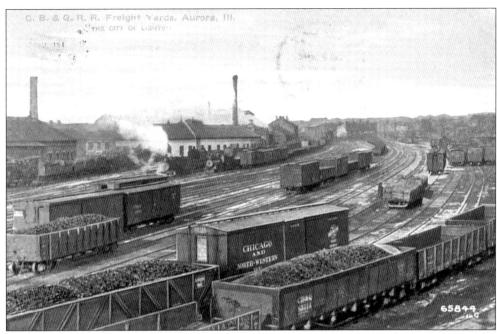

The CB&Q rail yard extended almost a mile along the Fox River on the north edge of the city. It was here that locomotives and cars were made and repaired. In 1909, five locomotives and thirty mail and baggage cars were made here. Repairs were made to 250 locomotives, 350 passenger cars, and thousands of freight cars. Each roundhouse could manufacture or repair about 22 locomotives at a time. (1)

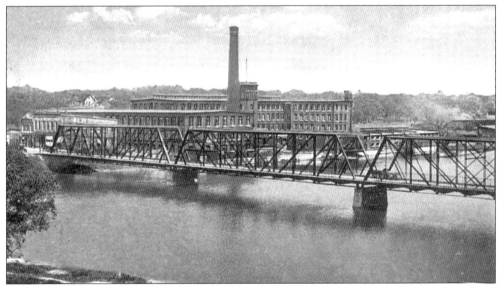

Aurora could have also been nicknamed "City of Bridges." Its early bridges were made of wood, and some were even covered where the river was not too wide. By 1887, the city had four metal bridges, not including the various ones used by railroads. This view is of a metal bridge with the immense cotton works behind it. The Bull Durham outdoor sign places this advertisement in the early 20th century.

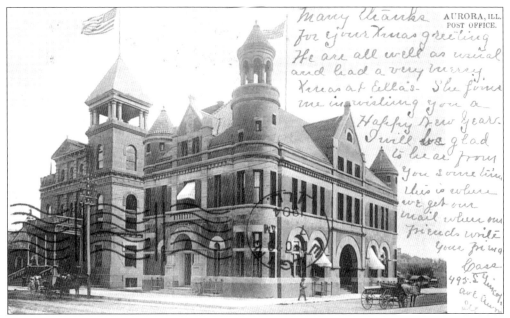

This downtown Aurora block was the heart of city services. In 1892, the post office was located in the city hall building on the left. A.J. Hopkins, local Congressman, paved the way for a new post office building next door on the right. Free delivery of mail began in 1886. Mail was delivered three times a day downtown and twice a day in residential areas.

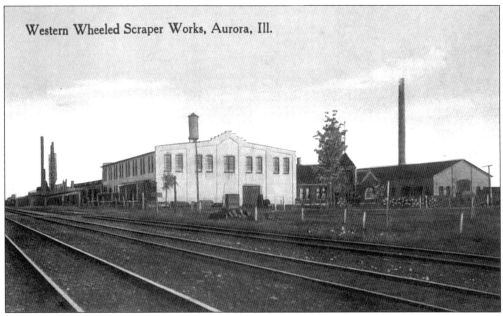

Western Wheeled Scraper Works moved to Aurora's east side from Mt. Pleasant, Iowa, in 1890. The company bought land south of the Burlington tracks for their factory and for development. They sold lots to the workers, who then built houses on them. The Scraper Works manufactured machinery used in the construction of the Panama Canal, and with seven hundred employees, it was at one time Aurora's second largest factory.

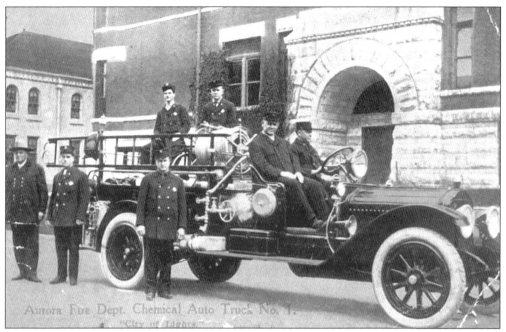

Aurora built its first fire station in 1856 to house a hook and ladder truck, which was drawn by two white horses. By 1875, the city had an Excelsior Steamer, which could draw water from the river to fight fires. This card, c. 1910, is of Aurora's new Chemical Truck #1. Note the large spotlight on the driver's side of the truck.

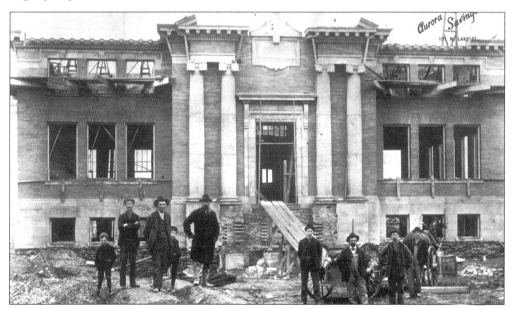

By 1885, Aurora had outgrown its library in the addition to the G.A.R. building. Andrew Carnegie donated $50,000 for construction of a new building, with the understanding that the city was to furnish a site and spend annually "a sum equal to at least ten percent of this amount for its maintenance." The heirs of J.G. Stolp donated the land for the building. The library was completed in 1904, and opened with a collection of 25,000 books.

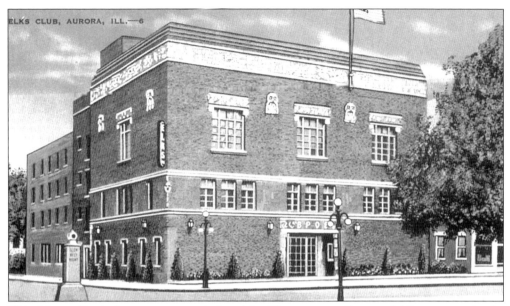

This Mayan Revival structure was designed by Zimmerman, Saxe, and Zimmerman in the 1920s, for Elks Lodge 705 and is located across from the library. The four-story building is reinforced concrete and faced with clinker brick to simulate primitive stone work. On each of the front corners of the building are stone Mayan face-masks decorated with vegetables and other Mayan symbols.

Cows were causing real problems in Aurora by 1876. They were roaming the streets and eating vegetation on the roadways and on private property. The old English tradition of a citizen's right to graze animals on public land died on May 6, 1876, when Aurorans voted 1,148 to 641 to end grazing on public streets. This ordinance also triggered the construction of picket fences to replace old board fences.

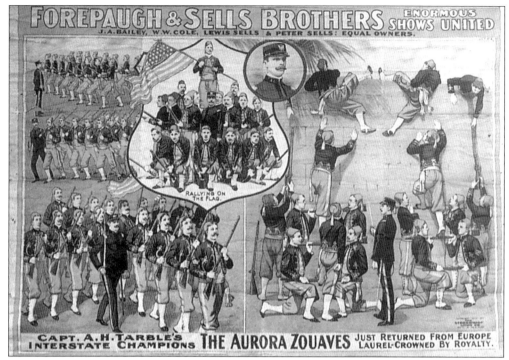

Aurora had world-wide traveling ambassadors from the gay nineties until World War I, with the Zouaves, a precision drill team. In 1896, they were said to be the best in the world. The Zouaves scaled walls with incredible speed and could climb over each other to reach the top of a 14-foot wooden wall in less than 20 seconds.

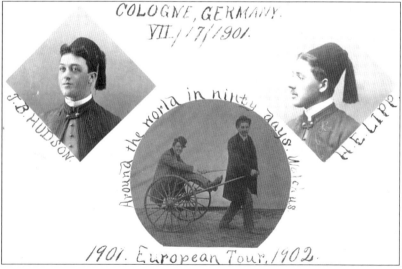

Le Journal newspaper in Paris declared the Zouaves the best-drilled soldiers in the world, and journalists in the United States called them the "great red-legged centipede." They served as honor guard for McKinley's funeral in 1899, and in 1901 and 1902, they toured Europe under the leadership of J.B. Hudson and H.E. Lipp. The group was reformed in 1936 and 1937, to parade for the Centennial Celebration. (1)

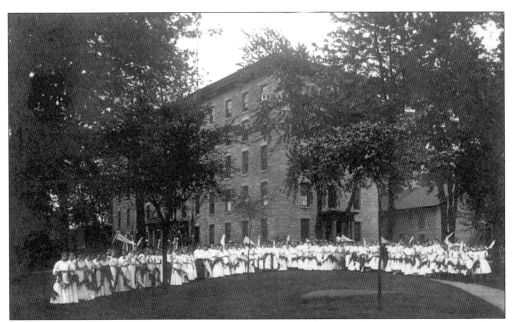

Lottie Kellogg was a high school senior who wrote a description of downtown Aurora in 1887. That essay was used as a basis for a chapter in Arcadia's Images of America, *Aurora, Illinois*, published in 1998. This recently discovered postcard of the Jennings Seminary, a fashionable finishing school for young ladies in Aurora, depicts its 1907 graduation ceremony. The message reads, "This is a view of my march at Jennings. Lottie." You don't suppose. . . ?

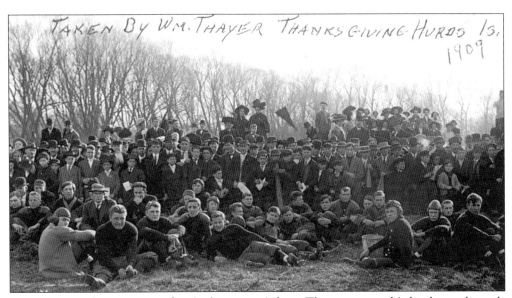

"East is east and West is west, but in Aurora. . . is best. The answer to this battle cry depends on whether you are an East or West Aurora football fan. The annual East-West game, originally fought on the neutral turf of Hurds Island, is strong medicine for local sports fans. This postcard shows the East Aurora team before the big game in 1909. Coach of the team that year was W.E. Shirley, and Captain Donald Downs led the team to a 5–5 tie with West.

The electric light was first introduced in Aurora in 1881, and a city directory for 1890 states that Aurora was "the first in the west to adopt the system for street lighting." L.O. Hill and John H. Pease's Brush Electric Light and Power Company supplied electricity for the city until 1886, when the city took over and ran the system from the water works pumping station.

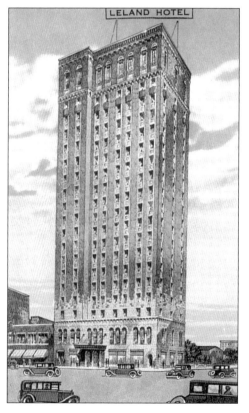

The 1934 World's Fair in Chicago, called the Century of Progress, prompted this Aurora hotel to produce this postcard noting that people could park and stop here on their way to the fair, take the train, and avoid congestion. This 250-room hotel featured a top floor Skyroom, where couples could dance to the music of live bands. Rooms rented for $1.50 to $2 per night. The Leland also had a coffee shop.

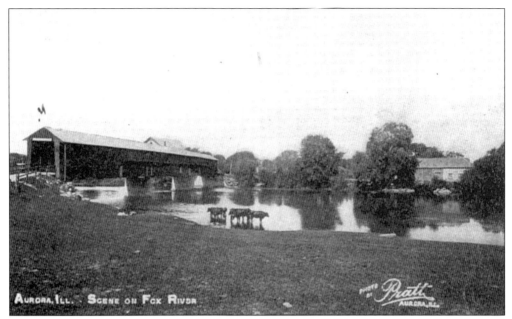

Wooden bridges along the Fox River, often swept away by rampaging waters, were replaced by iron and later by steel structures. According to early historians, an old covered bridge floated from Aurora to Montgomery in the great flood of 1857 where it was placed on new foundations. Others say that the bridge was one taken apart in Aurora, when it was replaced in 1868 and rebuilt in Montgomery.

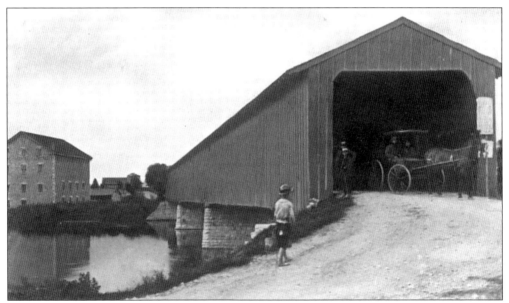

The bridge is shown in the view from the east side of the river. The large stone building to the left on the west side is a grist mill, built in 1851 by Gray & Watkins, and later run by Hord, Brodhead, & Company. A one-horse carriage is coming out of the covered bridge, as a young boy walks along the road approaching the bridge. The mill still stands, but the bridge was removed in 1914.

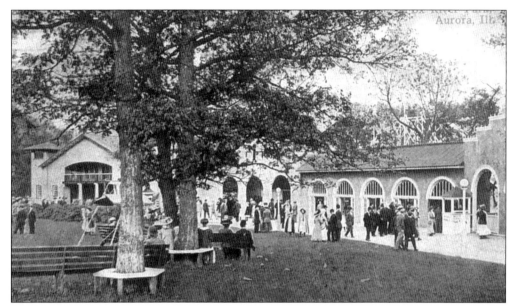

Although claimed on many postcards as being in Aurora, River View Park was actually in Montgomery. This view shows the entrances to the various attractions. Later, the park was named Fox River Park. An electric rail line that ran along the Fox River and connected to the Chicago line serviced this park. Among the most famous rides were the "Velvet Coaster" and "Tunnel of Love."

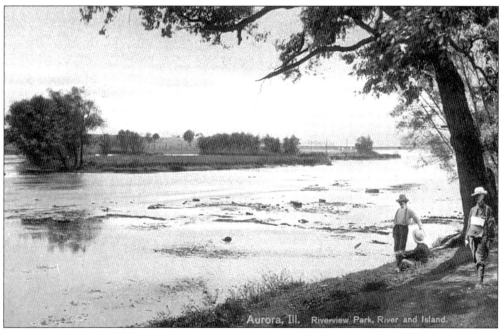

River View Park was one of the major attractions in southern Kane County. It had rides, dance halls, a carousel, a ball park, and a restaurant. These river-front viewers are on the opposite bank. The island shown was connected to River View Park by a bridge, which allowed park attendees to visit a pavilion building.

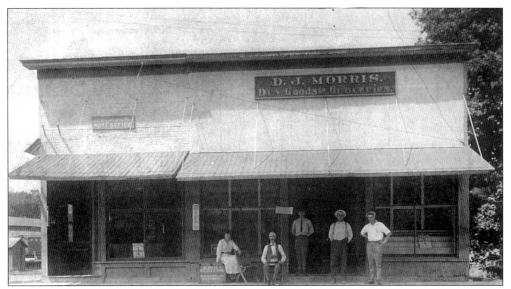

Most of the businesses that developed in Big Rock were established around the railroad tracks and related to farming. Joshua Rhodes, who opened his business in 1873, operated the first store in town. D.J. Morris had a dry goods and grocery store located in a building with the post office later on. Pictured, from left to right, are: Anna Lanterman, D.J. Morris, Arlic Jones, John James, and Staley Morris.

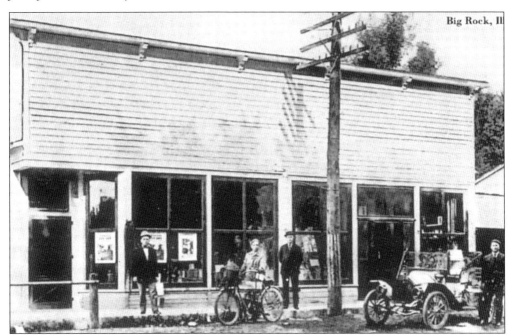

A later view of downtown Big Rock shows a scene featuring some of the village's most important citizens, mail carriers Leslie Whildin and Merritt Whildin. A very early touring car is shown on the postcard. Old homes in town were of the most popular styles of the late nineteenth century—Queen Anne, Prairie Square, and Bungalow. Many Queen Annes were built as retirement homes for wealthy farmers.

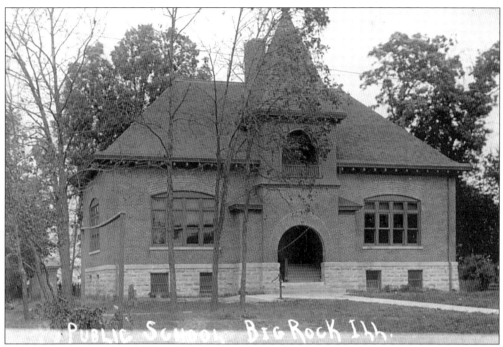

The Big Rock Public School, shown in this view, was a stunning Romanesque building. Reportedly, the Big Rock schools became the first consolidated school district in the state. The village's first schoolhouse was built in 1847 on E. Whiddon's land, but in the early 1840s, Colin Ament taught school in a log cabin.

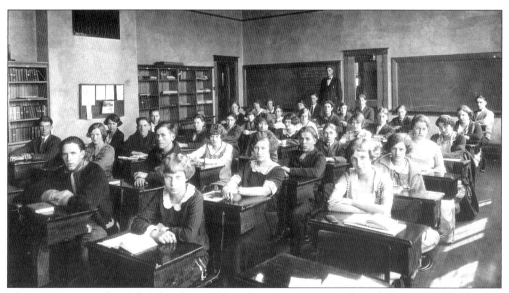

This is the Big Rock High School assembly of 1923–24. From right to left are: (first row) Alva Miller, Irene Richards, Bessie Davis, Grace Parish, Margaret Stuart, Gordon Thomas; (second row) Gladys Jones, Polly James, Laurence Miller, Dwight Williams, ? Claude, Roy Raymond, Harold Davis; (third row) ? Kinny, Wyle James, Ruth Gum, Mildred Bringham, Rachel Miller, Terrance Overgard, unidentified, and Alden Lindsley.

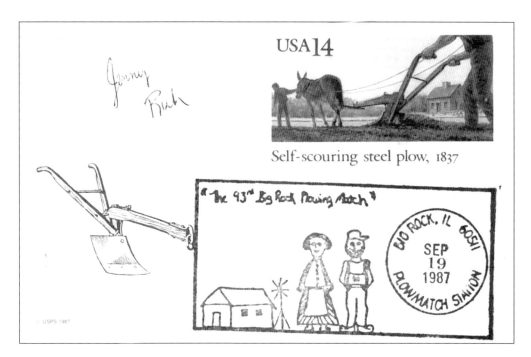

Big Rock has become famous for its plowing matches held each year. The federal post office authorized a special cancellation on the 14¢ postcard honoring the invention of the self-scouring steel plow, invented in 1837. The cancellation reads, "Big Rock, IL 60511, September 19, 1987, Plowmatch Station." This was the year of the 93rd annual match.

The first minister in Sugar Grove was Rev. John Clark, a Methodist minister already preaching to the Native Americans living in the area. The Methodists began to meet in a frame house built by P.Y. Bliss, which stood on the corner of Bliss and Merrill Roads. That building was moved to downtown Sugar Grove and now houses the Sugar Grove Historical Society. This view depicts the Sugar Grove Methodist Church, built in 1888 from an initial nest egg of only $80.

The first school built on this site was opened in the fall of 1875. The first year that school had 100 students, 25 being local, and a shed for 80 horses. Some time between 1887 and 1905, the district was reorganized as District 126. The building in this view was the second Sugar Grove "Normal & Industrial" school, constructed in 1906. The structure is no longer used as a school.

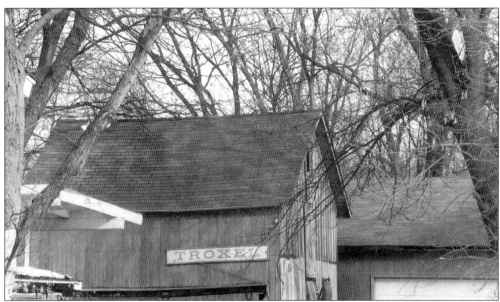

In 1905, the *Geneva Republican* newspaper noted that Troxel was established because the Illinois, Iowa, and Minnesota Railroad intended to use its sidings for coal chutes for their locomotives. The town was named for the surveyor who worked for the railroad. This old sign on the barn probably dates back to Troxel's early days.

Four

Batavia, Geneva, Mooseheart, North Aurora, Kaneville, La Fox

Batavia is situated on both sides of the Fox River, 2 miles south of Geneva. Christopher Payne is credited as being its first citizen when he settled on the east side of the river in 1833. For a while, his cabin served not only as a home, but also as a boarding house for as many as 16 to 23 guests, and it also served as Batavia's first tavern. Judge Wilson arrived in 1835, and began to turn the settlement into a real village. Known originally as Head of the Big Woods, Batavians initially received their mail at the Naperville Post Office. The first Batavia bridge was constructed across the Fox River in 1837. A six-arch stone bridge, made of Batavia limestone, was finished in the late 1850s. Early industries included a barrel factory, mills, a wagon and carriage factory, a paper mill, foundries, a cheese factory, and three wind mill companies. The diverse settlers of Batavia, from such locales as Germany and Sweden, formed many different churches. There was even an African-American Methodist Episcopal Church by 1865, with 25 members.

Geneva's first settler was Daniel S. Haight, who built a log cabin near Geneva Springs in 1833. The next year, he sold his claim to James Herrington, first store proprietor and first postmaster of La Fox—later named Geneva. The town had also been known as Herrington's Ford at one time. Most of it was owned by Herrington and by R.J. Hamilton. Geneva's first church was erected by the Unitarian Society, but by 1900, seven religious denominations were in town. The Girl's State Industrial School was established in Geneva in 1893. The town quickly grew into an elegant commuter town, with streets filled with homes of upper-class people, once the Northwestern Railroad offered quick passage into Chicago.

Mooseheart, dedicated on July 27, 1913, was a 1,023-acre estate on the Lincoln Highway, between Aurora and Batavia. It was built by the Supreme Lodge of the World, Loyal Order of the Moose, which was established by Dr. Jacob Henry Wilson in Louisville, Kentucky, in 1888. Mooseheart's purpose was to serve as a home, school, and family for the dependent children of deceased members of Moose lodges.

North Aurora was settled by John Peter Schneider, a German immigrant, and his family, who settled on the east side of the Fox River, near the intersection of Route 25 and Butterfield Road in 1834. He built a log cabin, cleared some land, and planted a garden. The area was known as Big Woods, with oak, maple, basswood, and walnut trees in abundance. There was also water to drive a mill, which he built by 1837. Mail was received at the mill until 1868, when a postal station was named North Aurora. Until that time, the settlement was known as Schneider's Mill. North Aurora, like many towns along the Fox River, had a large number of followers of the Congregationalist faith. They named their church the Union Congregational Church and built a sanctuary in 1863. Early businesses, besides a saw and grist mill, included a creamery and butter factory that shipped cheese to England; a small foundry that made pots, stoves, and cast iron products; and a door sash and blind factory. North Aurora was a stop on the C B & Q Railroad

and later was serviced by the interurban electric line from Aurora to Elgin.

Kaneville is located at the intersection of two old stage coach lines established in the 1840s. One road was between Aurora and Galena, the other between Batavia and Dixon. A post office was built by 1848, and it handled mail for all the new settlers from the New England states, Canada, and Europe. The first name used for the settlement was Avon, but the new postmaster, N.N. Ravlin, wanted his station to be called Royalton. Unfortunately, another town in Illinois had already chosen this name. The name Kaneville was finally chosen to honor former Illinois Secretary of State, Elias Kane, for whom the county was also named. When the town was platted in 1861, there were two churches, a blacksmith shop, schools, stores, a town hall, homes, and a wagon works in town. By 1870, Kaneville's population was 100. In 1907, the railroad, which ran between Aurora and DeKalb, came to town. Kaneville's boom years lasted until the railroad ceased operations in 1923.

La Fox was formed about 1845, when a group of farmers, mostly from New York, settled on this spot in Blackberry Township. Otis Jones and Joseph Shepard swapped their farmland in Galena and Chicago so that the Galena and Chicago Union Railroad would locate the Dixon Air Line through La Fox in 1854. Many railroad structures were built in La Fox. The post office and several houses were collectively known as Kane Station in 1860, and renamed La Fox after Geneva gave up the name. Lemuel Potter, a sea captain from Massachusetts, settled in La Fox in 1863, and quickly became the dominant force in the community with his multiple business interests.

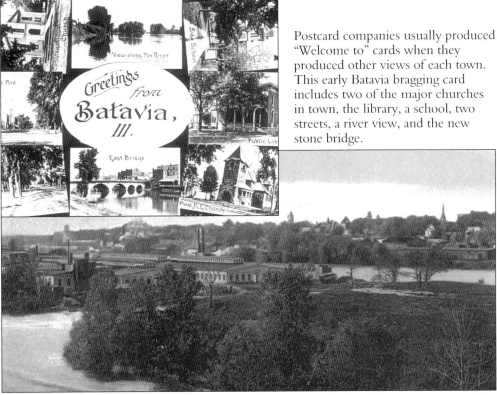

Postcard companies usually produced "Welcome to" cards when they produced other views of each town. This early Batavia bragging card includes two of the major churches in town, the library, a school, two streets, a river view, and the new stone bridge.

Here is a bird's-eye view of Batavia from the west showing the island with its many factories. The major structures running north on the island were the U.S. Wind Engine and Pump Company, the foundry, and the Wilson Street downtown buildings. Other factories on the southern portion of the island included a bag factory and a paper mill. The limestone quarries were located slightly south of this view.

The village's first Episcopal service was held nine years after the first settlers came to Batavia. The first church structure was located on the southeast corner of Houston and Washington. It was destroyed by a tornado two years later. This present stone church was completed in 1881, on the corner of Batavia and Main, a gift of John Van Nortwick. Two years later, the Van Nortwicks built a 15-room rectory two blocks south of the church.

This early view of Wilson looks from east to west. On the left was Lords and Fouteers Company. In 1892, there were still 28 wood-framed buildings along the street. The Baptist church is on the corner where the two girls are standing on the sidewalk.

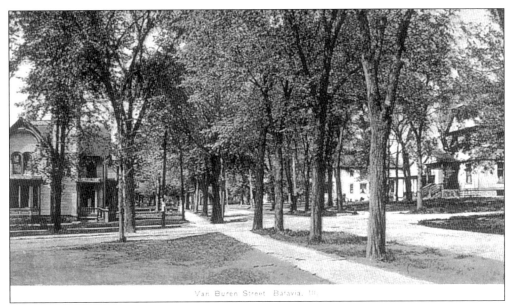

Van Buren Street, one of Batavia's prettiest old streets, runs north and south, high on a hill on the east side of town. Unlike Wilson Street and Batavia Avenue, it is not a mix of commercial and residential structures. For the most part, it was a street of middle-class houses with nearby churches. Among the residents on the street in 1909 were carpenters, general contractors, masons, a dressmaker, and a livestock dealer.

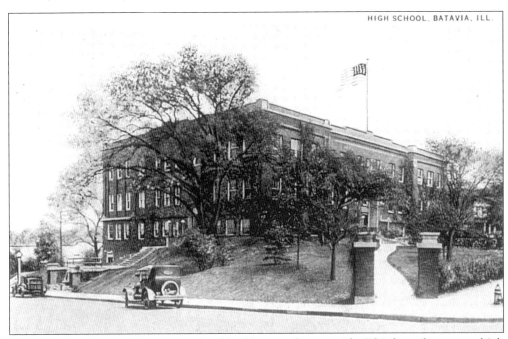

In 1885, "Old Main" was the only school building on the west side. This later three-story high school was erected between 1912 and 1915. Classes, particularly home economics classes, were held in a building to the south of the old high school. This had been the home of John Van Nortwick, but it was torn down to make way for the gymnasium addition in 1951.

Batavia Avenue, which runs north and south, was the main thoroughfare west of the Fox River. In 1910, one could find two saloons, two tailors, three doctors, a meat market, a lawyer, a druggist, and a hotel on this busy street. Also on the avenue were two bicycle dealers and Anderson's Green Houses.

First Street was Van Nortwick Street. It ran through the center of three of his additions to the town. The first addition ran from slightly west of Washington Street all the way down to the river. The boundaries of all three went from the section line to the west, south to Main, and north almost to Wilson.

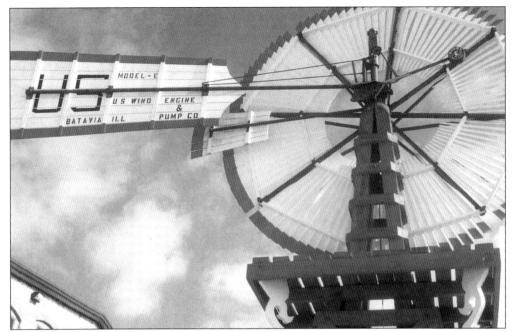

Daniel Halladay, who is reported to have invented the first successful self-governing windmill in 1854, moved his factory, United States Wind Engine & Pump Company, to Batavia in 1863. By 1887, the company employed more than 200 men. The above view shows one of the many models of windmills, Model E, made by this company.

Halladay's windmill factory later faced stiff competition from two other Batavia companies, the Challenge Company and the Appleton Company. The combined output of all three factories was enormous, making Batavia the "Windmill City'" of the United States. The postcard below shows the U S W & P works along the railroad tracks. One of Appleton's best selling windmills, the Standard Geared windmill, could be installed on a tall barn and used to drive corn shellers, straw cutters, threshing machines, pumps, saws, and other farm functions, turning a simple barn into a farmer's factory.

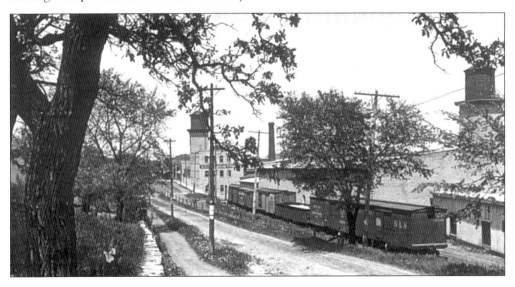

The Campana Company building is Batavia's most striking structure. This 1937 factory is a breathtaking, streamlined, modern building. Campana manufactured a product called Italian Balm, as well as other ladies' toiletries. In the 1930s, its products were shipped all over the United States. Campana saturated the print and radio media, and it sponsored one of the most popular shows on radio called "First Nighter."

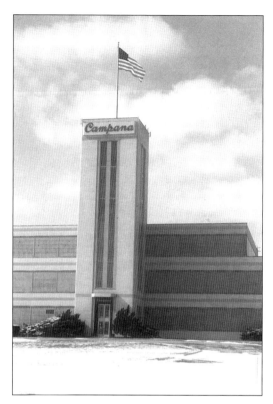

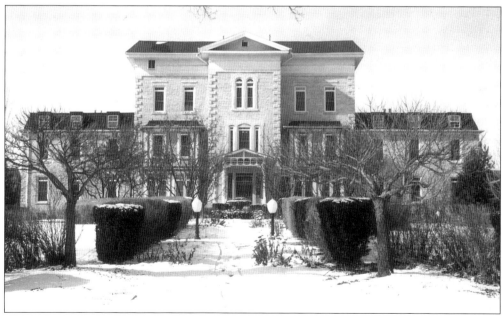

Bellevue was originally known as the Batavia Institute, a private school. Dr. R.C. Patterson converted the building into a sanitarium in 1867. The most famous patient of Bellevue was Mary Todd Lincoln, who was there for only a short time after the assassination of her husband, President Abraham Lincoln.

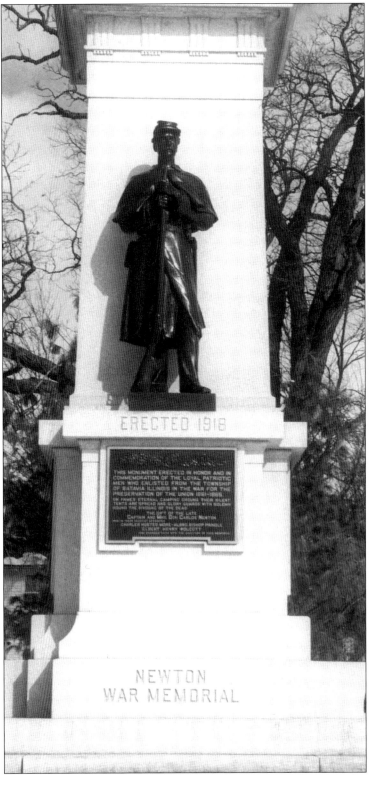

This monument to the soldiers of Batavia Township who fought in the Civil War was erected in 1918, and is located in the West Batavia cemetery along Batavia Avenue. The inscription reads, "This monument erected in honor and in commemoration of the loyal patriotic men who enlisted from the Township of Batavia, Illinois, in the war for the preservation of the Union, 1861–1865. On fame's eternal camping ground, their silent tents are spread, and glory guards with solemn round the bivouac of the dead." This monument was a gift of the late Captain and Mrs. Don Carlos Newton. Captain Newton served in the 52nd Regiment, Illinois Volunteer Infantry, a fighting unit in which the largest number of township soldiers served. Don Carlos, his brother Earl Cooley, and father Levi Newton built up a large wagon works along the Fox River in Batavia. Earl Cooley also manufactured a cow tie for safely tying cows in their stalls.

Batavia Avenue continues north into Geneva from Batavia. The avenue was less densely settled in Geneva than in Batavia. On the east side, there were only six residences in 1910, and on the west side of the road was the Aurora Brewing Company warehouse and just about three houses between Cheever Avenue, Eaton Avenue, and Peck Court. This early postcard reflects the almost rural setting of the roadway into Geneva.

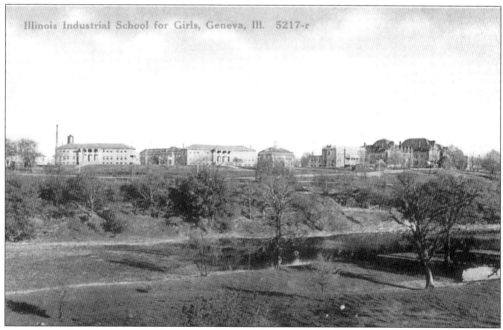

Sometime after 1893, Mrs. Julia Plato Harvey helped to establish the Illinois Industrial School for Girls. The land for the home was purchased for $7,000, and the total initial investment came to $137,000, which paid for the land and three buildings. By 1904, there were 236 girls, 100 of which were in private homes "on parole." This school was situated on a hill overlooking Route 25, a quarter of a mile south of downtown Geneva.

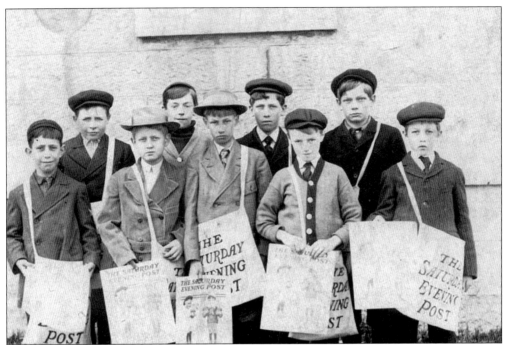

By the dawn of the 20th century, producers of goods in the United States had discovered that children, even though they could no longer legally make goods, were good vendors. Shown on this postcard is a less than eager group of young Geneva entrepreneurs preparing to sell the latest *Saturday Evening Post*. Pictured are B. Kirk, Tom Joyce, Art Skarin, Sunfeaf, Julius Alexander, Norman Schultz, Harwood Beasley, Donald Joyce, and Gilbert Skarin. (2)

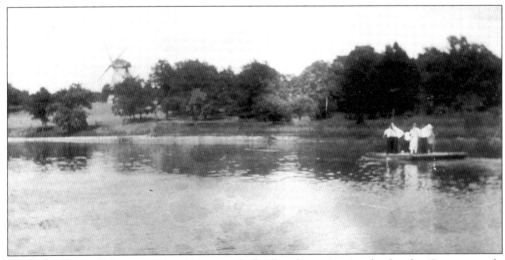

It was in Colonel George Fabyan's research facility that scientists broke the German code during World War I. He found an old windmill, purchased it, and took it to his estate for restoration. During the war, it provided flour to make bread and grind grain to feed his herd of prize Jersey cattle. This postcard shows the windmill in the distance with a raft or boat and its passengers on their way upstream toward the Fabyan estate.

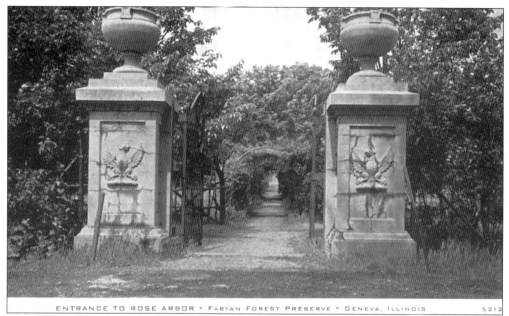

ENTRANCE TO ROSE ARBOR - FABYAN FOREST PRESERVE - GENEVA, ILLINOIS 5212

This view is of the entrance to the estate, which ran down to the river. The colonel had many interests—he invented cobless corn and a trench mortar, taught young women to sit up straight, raised peacocks, and maintained experimental gardens. His zoo included a gorilla and several bears. It is also said that he spent $100,000 trying to prove that Shakespeare's works were actually written by Bacon!

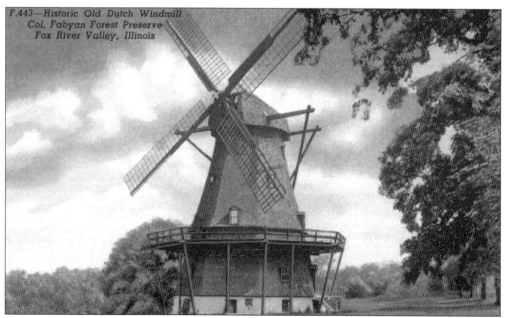

F.443—Historic Old Dutch Windmill Col. Fabyan Forest Preserve Fox River Valley, Illinois

The restoration of Fabyan's old mill was headed by a Danish millwright named Rasmussen. There are no nails anywhere in the internal structure of the mill. The entire windmill is held together with wooden dowels glued into drilled holes. The gears of the mill are made of wood, and there are five floors of mechanisms.

This view is of the main bridge in the spectacular Japanese garden on the Fabyan estate. The colonel once entertained the son of the Japanese emperor. To return the favor, the emperor sent his head gardener, Kobiyashi, to design this garden for Colonel Fabyan. The colonel was also a world traveler and collected items from his travels, many of which are displayed in the museum housed in his former home.

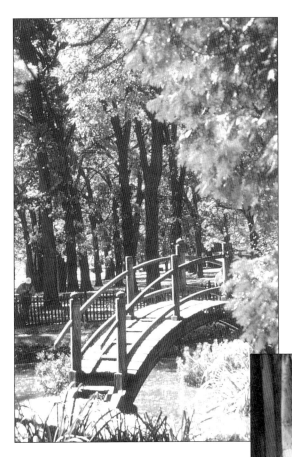

Postcards of home interiors with pictures of people are some of the most cherished and sought after. This is a picture of Emma Anderson, age eight, and Ida Anderson, age five, with their beautiful German dolls. Notice that Emma's hair appears never to have been cut. This view was taken on February 5, 1914. (2)

This postcard of the Hotel Geneva depicts the way the hotel looked after additions were made. The original hotel was erected by Timothy Worsley, who rented the ground level for shops. The hotel was the center of downtown activities according to a report in 1857. In 1911, there was a cigar and tobacco shop and billiards and pool parlor in two of the shops facing State Street. By the 1950s, Merra-Lee was in the corner shop.

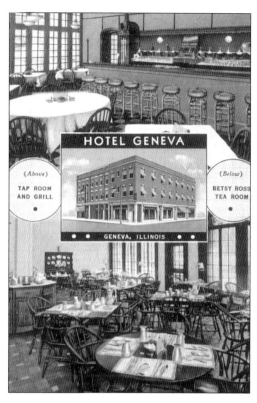

At the 1910 annual convention of the Loyal Order of the Moose, action was taken to establish a home and school for dependent children of deceased members of their fraternity. Three years later, Mooseheart was dedicated by Thomas R. Marshall, the vice president of the United States. This colorful souvenir folder of Mooseheart held over a dozen views of Mooseheart, Illinois, and Moosehaven, Florida, a senior center.

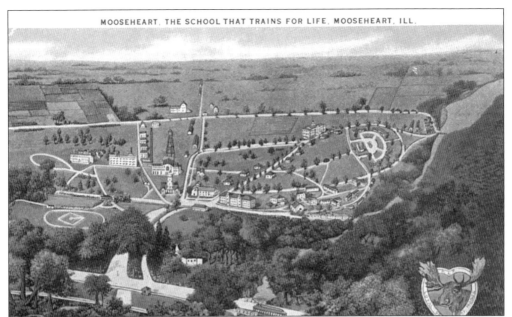

Mooseheart was maintained by the Order through annual dues and is administered by the Mooseheart Governors and a committee of the Supreme Lodge of the World, Loyal Order of the Moose. This bird's-eye view, taken by a student, not only shows the extensive grounds of the "Child City," but it also shows a trolley making its way down the avenue and the interurban electric line that laced together the Fox Valley towns from Aurora to Elgin.

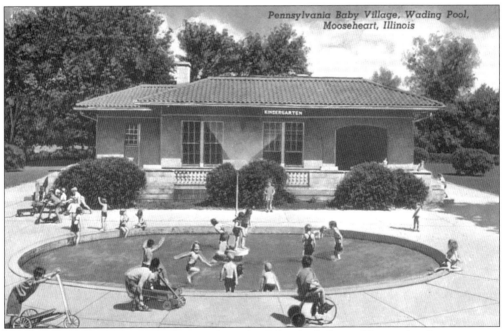

The wading pool shown in this postcard was built by the lodges of Pennsylvania as one part of a vast complex of five buildings arranged in a semi-circle called Baby Village. For many years, mothers could live in Mooseheart with their children after their husbands died.

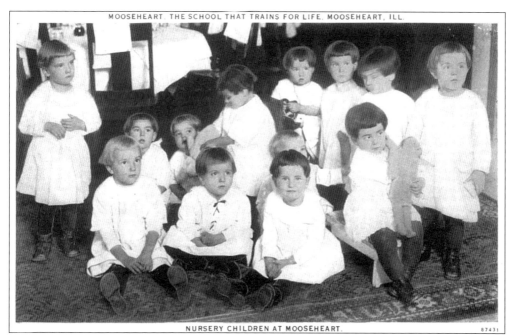

Mooseheart also had a nursery, as shown in this picture of children, one of which is clutching her rag doll. Notice that the table in the background is set for a family-style meal. When this card was made, children were housed in individual homes. Each house had 16 to 30 children with a house mother and cook. Mooseheart maintained a 70-bed hospital, built by the Philadelphia Moose Lodge No. 54.

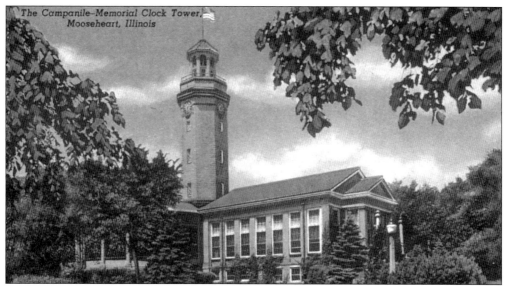

Mooseheart is open to daily visitors, who must register at the P.J.O. Centre. They once registered in the Campanile, the clock tower building shown here, which was built to honor the founder of Mooseheart. Visitor tours to this "child city" and school can be arranged. Special concerts featuring Mooseheart musicians were once held in the Theodore Roosevelt Memorial Auditorium each Sunday afternoon, except during the summer.

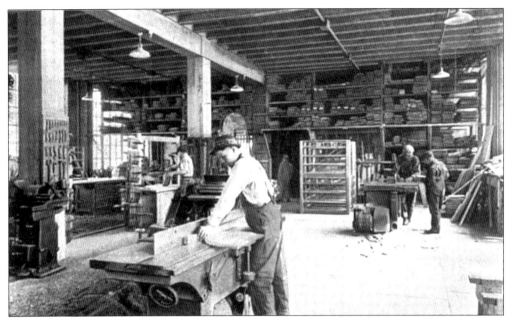

Mooseheart was a "child city" that offered vocational skills to its students. Its location on the eastern fringe of rural Kane County offered many opportunities for its young charges to learn farming and other vocations. As shown in this view, boys were taught woodworking skills. (1)

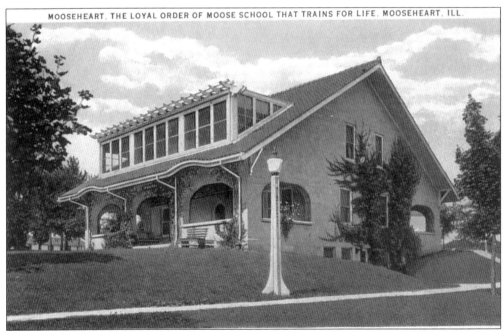

The Women of the Mooseheart Legion donated the house shown on this postcard about 1930, judging by the building's architecture. Notice that the houses are all situated on streets with sidewalks and street lights, giving the entire area the feeling of an ordinary town. Mooseheart buildings were heated from a central heating plant that also generated electricity and hot water.

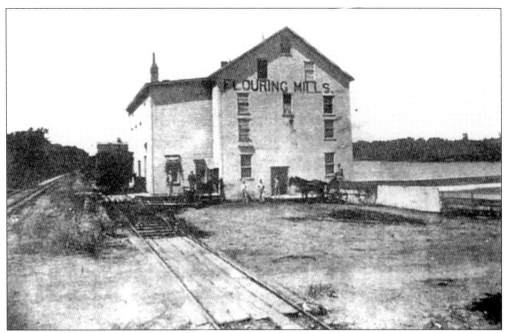

This early picture of North Aurora shows the flouring mills, located on the west bank of the Fox River around 1895. It was known as the North Aurora Mill Company in 1888, and prior to that as the North Aurora Manufacturing Company in 1874. John F. Schneider and his father, a farmer, millwright, and carpenter, built the first grist mill in 1862.

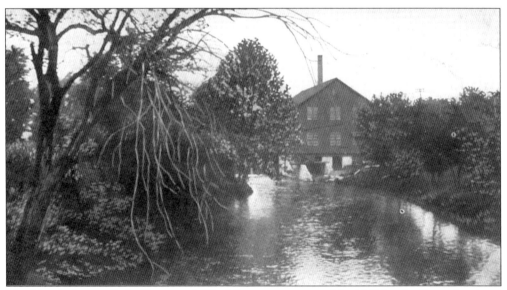

The North Aurora Sash, Door, and Blind Factory was started in 1869 by the Stone brothers, Richard I. Smith, I. Tiffany, and Julius Brown. Eventually they constructed another building across the millrace. As many factories did in the early stages of industrialism, they located along the Fox River and used races to create water power to drive their machinery. Once electricity became cheaper, factories could abandon their river locations.

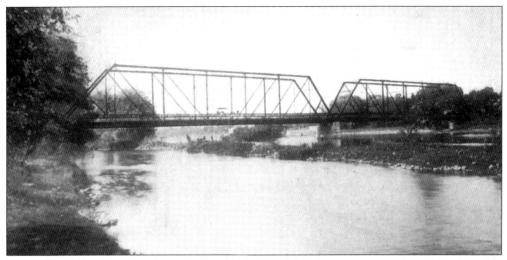

As in other cities along the river, the first bridge in North Aurora was wooden and vulnerable to floods. The next generation of bridges, which were built in the later 1800s, were made of iron or steel and were better engineered. Notice that this bridge at North Aurora (1887) spans the Fox River with only one limestone support placed in the river.

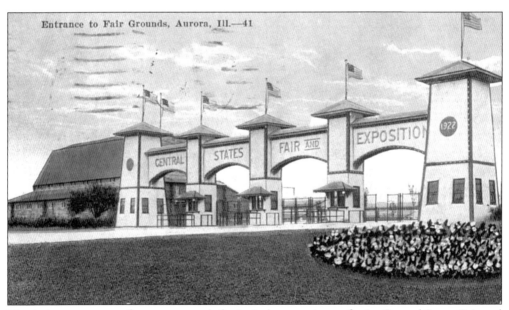

North Aurora was not famous so much for its industry as it was for its Central States Fair and Exposition. This card shows the entrance to the fairgrounds in 1923. Twenty-four buildings were inside. The largest steel and concrete grandstand in America, with 10,000 seats, was along a half-mile-long racetrack. A massive log cabin and a swimming pool, each touted as the largest in the world, were also part of the show.

Kaneville was born in the 1840s, with its first store appearing in 1852. The store had various owners until about 1876, when it was owned by J.H. Scott, who reported annual sales of $35,000 to $40,000. This one-room doctor's office might well have been the office of Ralph H. Hardy, who was not only a manager of a general store in Kaneville but also was the town physician and surgeon.

Kaneville, like other Kane County settlements, had many churches. Baptists began to meet in 1847 in the frame schoolhouse. At about the same time, the Methodist Episcopal denomination met at the old schoolhouse and in a home. The postcard above shows the cemetery in Kaneville surrounded with a beautifully ornate iron fence.

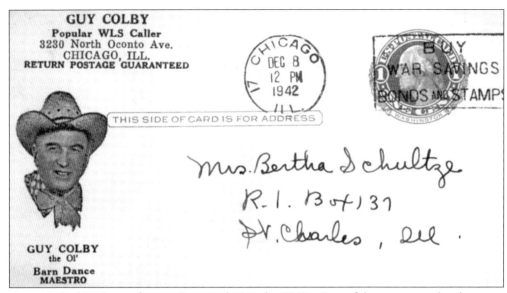

Kaneville had its share of entertainment during the 1940s. One of the most popular shows on Chicago radio station WLS was their "Barn Dance, with Guy Colby as the ol' Barn Dance maestro." Long's barn, located 2 miles south of Kaneville, was the site of square dances—especially those conducted by Colby with the Lindy's Fiddle Band. The postcard appeal to save gas and "Buy War Bonds and Stamps for Victory" was prominently featured on the back.

Lemeul Potter's home, shown in this view, was the most striking home in La Fox. Potter was the leading citizen in the village. He and Barker erected a cheese factory in 1869, which later was expanded to include a creamery. A 7,000-bushel storage elevator was built along the track, and in 1878, Potter and Barker added a large warehouse building. Business is still conducted in La Fox out of the original building. In 1892, the main road through town was called Public Highway.

Five

St. Charles, Lily Lake, Elburn, Virgil, Wayne, Wasco, Maple Park

Settling of St. Charles began in 1833. Dean Ferson and his brother settled on the west side of the river and built a log shanty. Elijah Garton and his family also built a log cabin in the township around the same time. Garton came prepared for the frontier. He had a wife, six children, 100 sheep, 100 cattle, six pairs of oxen, and many horses. "Squatters" begin to flock into town, and by 1837, there was not an acre of land in the village worth having that was not already taken. St. Charles was originally known as Charleston, but in 1839, discovering that Illinois had another town by that name, the name was changed. The first child born in St. Charles arrived on Christmas Day 1837, and was appropriately named Frances Christmas Howard. At this time, the village had its first store, and there was a dam across the river with a saw mill on the eastern shore. Hotels and taverns were in St. Charles before 1840.

Early settlers brought their religions with them. The various denominations first met in homes, but later the downtown had formal houses of worship where Congregationalists, Baptists, Universalists, Methodist Episcopals, and Catholics could worship. Political and social news is the lifeblood of any community. The first newspaper in town was the *St. Charles Patriot*. By 1871, St. Charles had seen seven newspapers come and go!

In the 1870s, St. Charles was part of the post-Civil War prosperity. Industries in town included Brownell & Miller Paper Mill, S.L. Bignall Hardware Company, Louis Klink's Wagon and Carriage Shop, and the St. Charles Dairymen's Association. The association had a factory that processed products for the members who lived within a 5-mile radius of the city. In December of 1877, they processed 300,000 pounds of milk, 24,000 pounds of cheese, and 7,750 pounds of butter. St. Charles was doing its part to feed the multitude in Chicago.

Lily Lake was once called Canada Corners. The first settler was an Englishman, William Kendall, who arrived in 1836, followed by several Canadians the next year. A store was built at the corner of Route 47 and Empire Road in 1847, by Eldridge Walker. In 1872, Lily Lake was the largest hamlet in Campton Township with a school, two blacksmith shops, a paint shop, and fourteen homes. Dairyman Welford A. Read, who owned 50 cows, was shipping 120 gallons of milk daily from Lily Lake in 1908.

Elburn was first called Blackberry Post Office, and then Blackberry Station. It was platted in 1854. In 1882, Quincy G. Shelton put up a butter and cheese box factory, and in 1883, Mrs. Celia Ida Markle opened a store in town with "carefully selected lines of ladies' goods." By the turn of the century, Elburn had a depot in front of double railroad tracks with four spur sidings, Meek's Mill, a town hall, a public band stand and park, and three hotels.

Virgil began as a settlement of three families in 1836. Its first log schoolhouse was built in 1839, and the teacher, Simeon Bean, was noted as a "profound thinker and scholar [rather than] a disciplinarian. Little boys and girls shot paper wads at him, while he was treating the

intricate labyrinth of Euclid. . . ."

Wayne, originally called Wayne Station, was founded by John Laughlin and Robert Benjamin in 1834. Two trains a day were stopping in Wayne in 1851. At this time, the village had a depot just south of Army Trail Road, an inn, and a small house. The western part of Wayne is located in Kane County, where the famous Dunham estate properties are found.

Wasco was settled by farmers from Massachusetts and New Hampshire in the late 1930s. Farm families from Sweden came in the 1870s. Wasco prospered as a railroad town starting in 1887.

Maple Park was platted in 1854 as the town of Lodi. Within 18 months, the village had 400 people. At the time, there were two stores, a tavern, and a blacksmith in town. Henry Ziegler was selling coal in 1908, and Preston Keefe's livery barn had an electrically lit bowling alley!

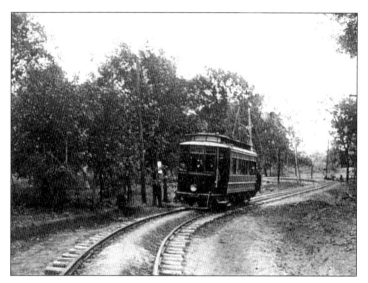

Starting in the late 1890s, the towns along the Fox River from Elgin to Yorkville had their own electric railway system. It even connected to electric rail systems in the west and into Chicago and points east. In those portions of this system in areas where people or animals might touch the rails, a "third rail" was run overhead. This card is titled, "Coming Into St. Charles."

This postcard view shows Main Street looking east. In the 1870s, the citizens of St. Charles were required to raise $35,000 for the Chicago & Northwestern Railroad to lay track connecting to the main line in Geneva. Animal-drawn carts and wagons were still used to get consumer goods to the downtown stores in this era.

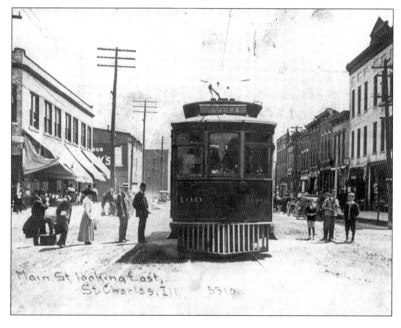

70

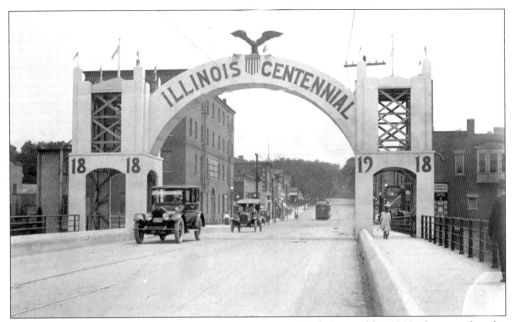

Notice how much the downtown street in St. Charles had changed by 1918, the year that the Illinois Centennial Memorial Arch was constructed. Carts and wagons are gone, and gasoline cars and trucks were in use all across America. What a sight—only two cars on the road with a trolley in the distance. Oh, for the good old days!

This view is of one of the largest businesses in early St. Charles, Colson's Department Store. This building still stands on the busiest corner of St. Charles, but Colson's did not survive into this century.

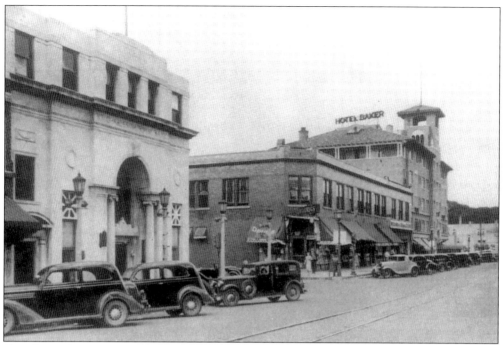

Skip forward in time to the 1930s, and see Colson's Department Store again in this view. To the left, across the street, was the pink marble exterior of St. Charles National Bank. Beside the Colson Building is the Mediterranean-style Baker Hotel and Gardens, famous throughout Chicagoland for its plush accommodations and superb service staff.

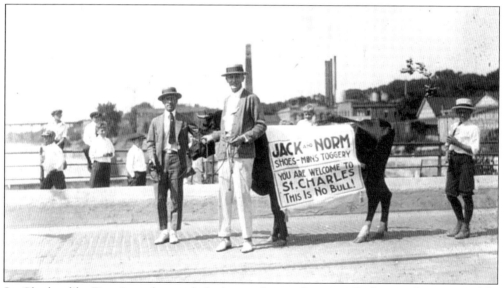

St. Charles, like Batavia to the south, had some interesting ways for its merchants to peddle their wares on the streets during parades. Batavia had women with clothing covered with the goods sold by the various merchants. St. Charles, however, wins the prize in this c. 1910 postcard featuring Jack and Norm's Shoes and Men's Toggery Store's bannered cow promising that you were welcome not only to their store but also to St. Charles—"no bull!"

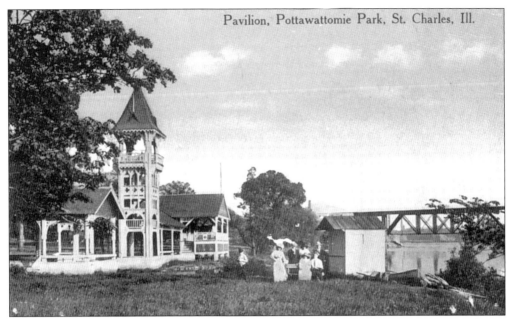

Pottawattomie Park in St. Charles is named after the city's first actual settlers, a tribe of local Native Americans. By the 1920s, this park had become a favorite Fox Valley location, where one could go for good, clean fun. This early 20th-century view, shown above, depicts the high Victorian gingerbread style of the park's pavilion used for dances and a fancy tower for observing the surrounding landscape. A group of upper-class men and their fancily-dressed ladies are also captured. The old iron bridge that spanned the river as part of Main Street is in the distance. St. Charles' own brass band played on special occasions for picnickers, strolling couples, and children in the park.

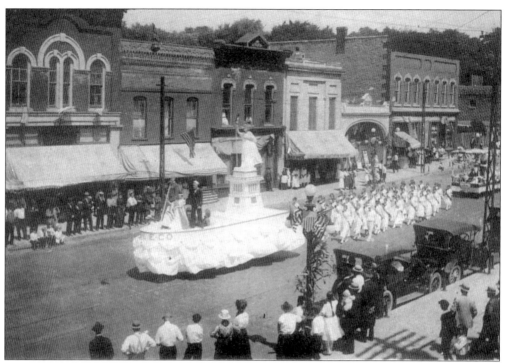

Parades have always been a favorite American spectacle, and they were especially popular in the years following World War I. This parade honors what may have been a Fourth of July parade. This 1919 postcard shows a fancy float, with someone playing the part of the Statue of Liberty, and a marching unit of women behind the float. American flags are everywhere—on light poles, flying from store fronts, and featured on all the floats. The lower picture is from a 1922 parade for St. Charles Day. Balloons and smiling young faces attest to the fact that no one enjoys community parades more than the young people.

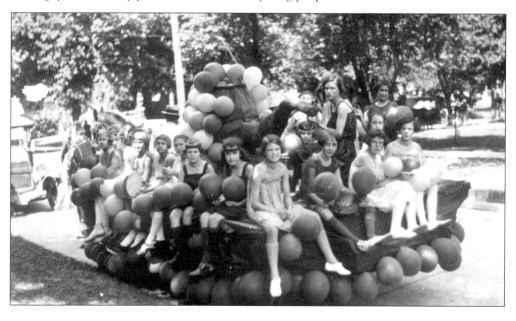

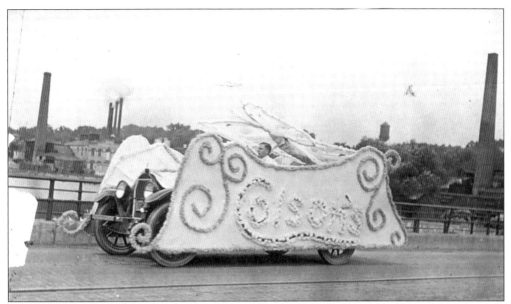

This view is of a car decked out with side panels to make the float look like an old fashioned circus wagon. "Colson's" is spelled out on each side of the float, which represents the landmark department store. The float is photographed as it crosses the Main Street bridge over the Fox River on Main Street.

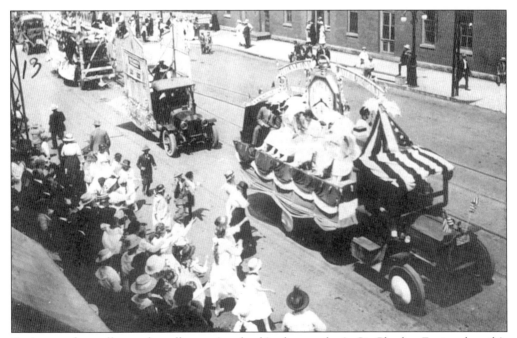

Businesses from all over the valley got involved in the parades in St. Charles. Featured on this postcard is a flag-covered and highly-decorated long-bed truck, with pretty girls surrounding a large time piece advertising the Elgin watch, famous all over the world.

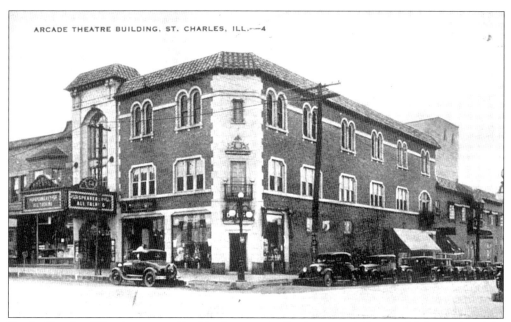

By the Roaring '20s, downtown St. Charles was the "cat's meow." One could dance the night away on the Baker Hotel's glass block ballroom floor, with its 2,600 colored lights, or catch a performance at the town's newest movie palace, the Arcada, after 1926. The theater could seat 1,000, and specialty shops lined the arcade leading into the movie house.

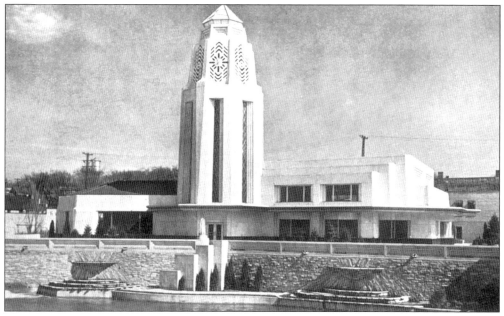

One of the most striking government buildings in Kane County is the 1940s Art Moderne Municipal Building in St. Charles. Still used as a government center today, it features a unique multi-faced tower, which is bathed in colored lights at night. Located on Main Street on the east side of the river, it is a commanding building, as streamlined as a Burlington Zephyr superliner train.

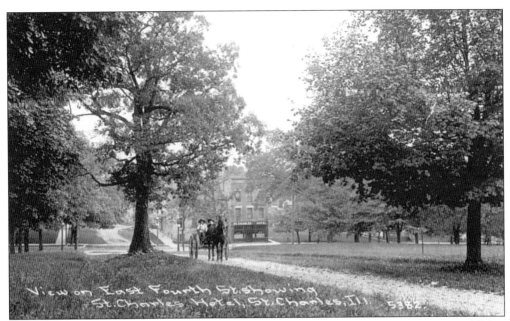

The first hotel in St. Charles was built by David Howard in 1837. Later, there was an addition made to the west end of the building. It was known as the St. Charles Hotel and was managed by P.J. Burchell. William Knight had a tavern in the hotel for a time. It was here that the first public ball was held in St. Charles. This view of the hotel shows East Fourth Street, with its still crude, undeveloped streets.

One of the other great public buildings in St. Charles is the Henry Rockwell Baker Memorial Community Center. It was designed by architects Wold, Sexton, and Truex in a stately blend of Tudor and Gothic styles. Local workers crafted its leaded windows. The structure had half-timbered stucco walls, a slate roof, and ashlar stone and brickwork. Notice that the street lights at the time of this card are similar to the street lights in Aurora.

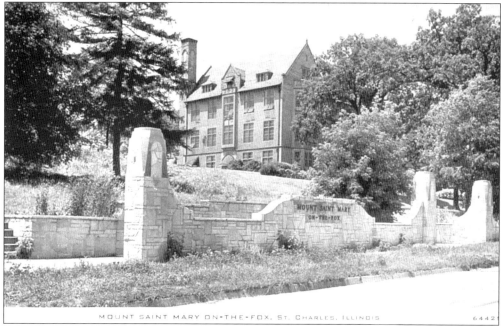

The Sisters of St. Dominic opened their St. Mary's Academy on the west bank of the Fox River in 1907. This large, three-story building was designed as a stately English Manor house with Gothic pillars guarding the entrance. The interior was finished in oak with carvings. The academy was designed as a boarding school and gave the following as a mission statement: ". . . with God's grace, to form good Christian women, useful and accomplished members of the home circle. . . ."

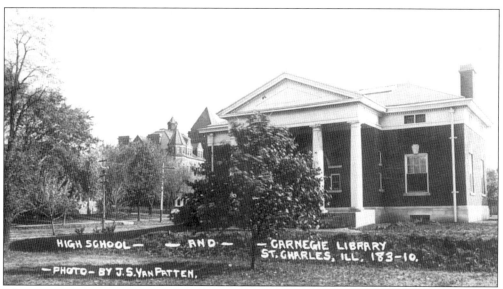

All across the United States, Andrew Carnegie gave millions of dollars for community libraries and church pipe organs. In St. Charles, he donated $12,500 towards the total expense of $15,000 necessary to build this library in 1906. Before the Carnegie "free library," the city had a subscription library where patrons paid a $2 annual fee.

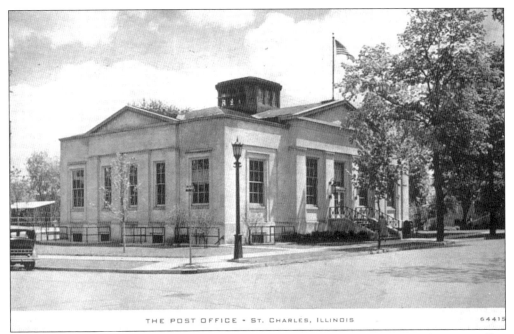

THE POST OFFICE - ST. CHARLES, ILLINOIS

The early settlers of St. Charles had to go to Elgin to receive their mail. The first post office was built in St. Charles in 1837, with Horace Bancroft as postmaster and Calvin Ward as the mail carrier. It is recorded that Bancroft picked up the first batch of mail from Elgin and took it to St. Charles in his pocket handkerchief! This postcard shows the Federal-style post office, which was built 100 years later in 1937.

The massive buildings of the Cable Piano Company dominated downtown St. Charles, since they were located immediately south of the Main Street bridge on the west bank of the river. This factory once produced 35 pianos a day and employed 500 skilled workers. The Kingsbury piano, a lower grade of Cable piano, was made at the St. Charles factory, as well as Wellingtons, Conovers, and Eureka player pianos.

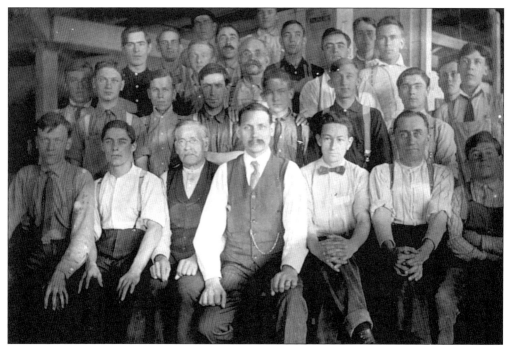

These hardworking men are skilled workers, perhaps from the Cable Piano Factory, which also employed skilled women. In some departments, men and women worked side by side. The age range of this department seems to go from teenagers to very elderly workers.

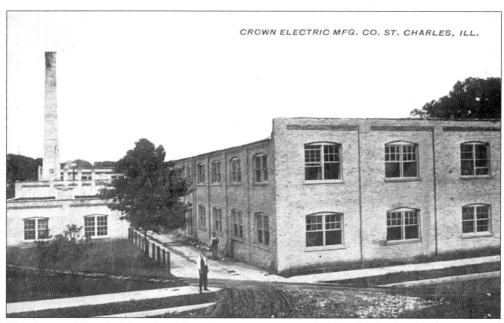

The Crown Electric Manufacturing Company came to St. Charles in 1892. This postcard dates from about 1910. Crown first manufactured gas lighting fixtures, but when electric power plants sprang up in the Fox Valley, it started manufacturing electric light fixtures. Their customers were offered a choice of over 700 differently designed chandeliers.

St. Charles had its share of former slaves who located here after the Civil War, most finding work as domestics. Joanna Garner was a runaway slave who, instead of continuing on to Canada, stayed in town. Shown in this postcard are her grandchildren, William and Harriet Luckett. William trained at the Art Institute of Chicago and eventually worked as a commercial artist, while his sister fostered over 40 children while living in "Belgian Town" on Dean Street.

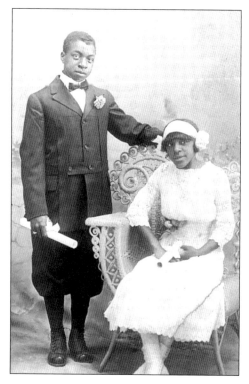

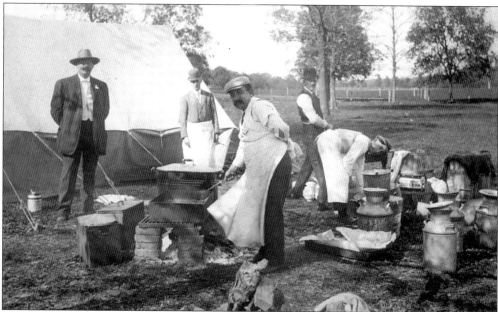

People all across the country loved to picnic outdoors during the late Victorian era, and the people who visited St. Charles were no exception. They "tented" all up and down the Fox River. Women had to look elegant, which greatly reduced their ability to move or to engage in any athletic pastime. The men, free of restraints, were able to relax and cook up some serious victuals. The gentleman in this postcard, on the left with the fedora hat, is Otto Frelsen.

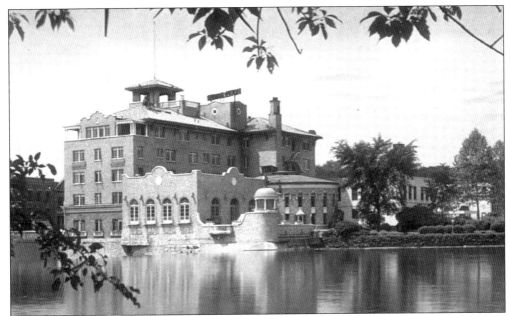

Hotel Baker is viewed in this card from the east bank. Built in 1928 at a cost of $600,000, it quickly came to be called the honeymoon hotel. Originally, the hotel had its own source of electrical power, which came from turbines in the basement which were run by water power from the Fox River. After a time as a retirement center, the hotel was restored and reopened once again as a hotel in 1998.

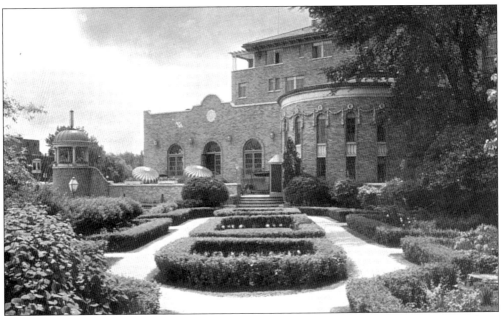

Behind the hotel was an elaborately landscaped garden, full of 150 rose bushes, privet hedges, tulips, a rock garden, and a goldfish pond. There was an observation platform and a patio for dining outdoors, which was connected to the famous Rainbow Room. For those who wanted to arrive by motor launch, there was also a boat dock.

This sunset postcard of the Fox River at St. Charles shows one of the many dams built on the river. Dams were first built by the early settlers to divert water into narrow chases on either side of the river as a power source for machinery. Today, people are questioning dam systems along the river, claiming that they do ecological harm and endanger lives in and around the river.

The Congregational Church of Lily Lake on Empire Road is pictured here with its impressive stained-glass windows. There was a store in town in 1902, where one could go for supplies as well as a depot for the Chicago, St. Paul, and Kansas City Railroad. Some dairy farmers in this area specialized in Poland China hogs and Plymouth Rock chickens as well.

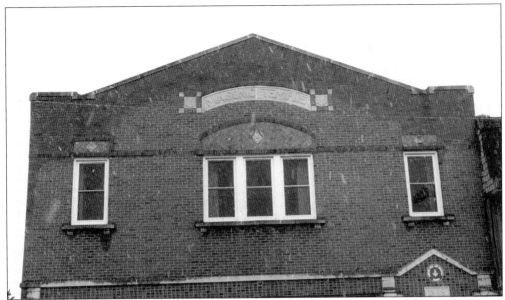

Most larger towns in Kane County had a Masonic Temple, as well as other secret societies. Elburn residents organized Lodge Number 359 F. & A. M. in 1855. This is a view of a building that was constructed in 1919, with retail space on the first floor and a meeting room for the Masons on the second floor.

This is the turn-of-the-century Elburn Meat Market, an Elburn landmark. Most two-story buildings of this type had the shopkeeper and his family living upstairs. The purpose of the three window bays on the second floor was to allow more natural light to filter into the apartments. All kinds of merchandise was sold in early Elburn shops—hardware, furniture, coal, lumber, grain, and farm implements.

Old downtown Virgil was very compact, with most of the buildings on one side of the street, as this postcard illustrates. Many successful farmers made enough money to build a town house in Virgil. Michael Huss, for example, had 2 acres of land in town. He also maintained a dairy and a farm. Farmers took their milk to Virgil for shipment, and one farmer with eight cows was delivering a record 24 gallons of milk daily to the station.

A Catholic church and parsonage were built about a quarter-mile south of Virgil on Meridith Road. This church is an impressive brick Romanesque Revival structure with elaborate stained-glass windows. This view shows both the church and parsonage. One of the first businesses in town was a log cabin tavern, which opened in 1840. In 1847, the post office station was named New Virgil.

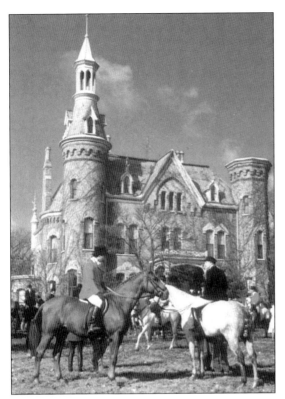

The architectural jewels of downtown St. Charles are the Arcada Theatre, the Baker Hotel, and the sleek Municipal Building. The surrounding countryside has the spectacular Dunham Castle, located on the western fringe of the Village of Wayne. The 70-by-100-foot c. 1880 structure is three stories and is patterned after a French chateau. This castle is a pleasant blend of Norman and Gothic architectural styles. There are over 25 rooms in this castle built by Mark Dunham. The castle was situated on a 3,000-acre estate, which had five barns and 600 feet of stables, called Oaklawn.

The old homestead that Mark Dunham inherited from his father, Solomon, is now the Dunham Woods Riding Club, which is famous today for entirely different breeds of horses than the Percherons introduced by Dunham. The graceful animals shown in front of the castle come from many stables in Wayne and St. Charles for the hunts that begin at the castle.

George Bergland was a farmer who ran the lumberyard in Wasco and was its first postmaster. His first building was demolished and replaced by the present structure, which dates back to 1887. This building still houses a post office on the left side of the building and a general store on the right. At the turn of the century, a blacksmith shop, which had been beside the Bergland Building, was moved across the street.

Another landmark Wasco building, shown in this view, is the beautiful 1891 Baptist church on La Fox Road, a block south of Route 64. As farmers came out of a depression in 1909, land prices jumped drastically. Many farmers sold off portions of their land close to the village of Wasco, triggering a residential building boom. The village, then and now, is surrounded by farmlands.

This two-story building was the old Maple Park Town Hall, which had an "Opera House" upstairs. It was built in 1887, and the second floor stage and hall was used for firemen's dances, church suppers, and other public functions such as political meetings. At one time, the town library was in this building. It is currently undergoing renovation by a private party.

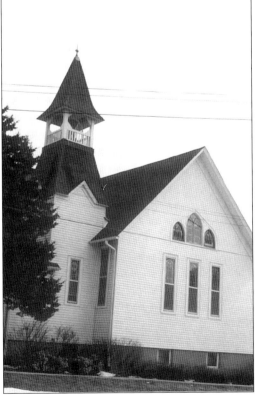

Grace United Methodist Church in Maple Park was built in 1854. Its clean vertical lines identify the church as being constructed in a time when fanciness was not tolerated by farmers in their barns, houses, or churches. This church was moved several times and came to rest here, at 506 Willow, in the early 1900s.

Six
Elgin, South Elgin, Plato Center, Burlington

Elgin's first settlers were James T. and Hezekiah Gifford, who arrived in 1835. Hezekiah built the first hotel/tavern. Elgin had its first dam, bridge, and sawmill in 1837. In 1843, a woolen factory was built, and in 1853, the city was incorporated. The Borden Condensed Milk Factory was in Elgin by 1866, and by the end of the 1870s Elgin had an iron works, butter factory, brick factory, foundry, shoe factory, soap factory, and even a chewing gum factory! The center of the city where all the major roads intersected was first called Market Square, and later when a fountain was installed, Fountain Square. By 1900, the city had seen about a dozen different newspapers begin and fold. The largest newspapers around 1908 included the *Elgin Advocate, Elgin Daily News,* and the *Elgin Daily Courier.* The greatest single economic force in Elgin, besides its dairy industry, was the arrival of the National Watch Company in 1866. Its world-class watches dominated the entire watch industry for a time.

Other Elgin goods that sold well were the goods from the Elgin Silver Plate Company, which sold goods in Southeast Asia, South America, England, Canada, and Japan. The Bibles, tracts, picture cards, and other religious publications of D.C. Cook Publishing Company were sold all over the world. Trade unions came to Elgin in 1875, and there was a watch factory employee strike in the 1890s, and a carpenter's strike in 1905. The period of time from 1900 to 1905 saw dozens of new unions form up and down the Fox Valley—especially in its larger cities of Elgin and Aurora. By 1908, Elgin had 23 skill-based unions, but no whole-factory unions.

South Elgin, located 3 miles south of Elgin, was first called Clintonville. The first settlers—Joseph P. Corron, Truman Gilbert, Dr. Joseph Gefft, and Dr. Nathan Collins—arrived in 1835 to 1836. Two members of this early group built log cabins where the Ballantine Distillery stood later in the century. South Elgin's first dam was built in 1836, but it flooded away the next year. A frame schoolhouse, used for religious gatherings, was built in 1850. The Galena & Chicago U.R. Railroad completed tracks into South Elgin later in the winter of 1849, and by 1900, the village had several flour mills, a distillery, a paper mill, a tannery, and an iron foundry.

Plato Center was actually not one center but was developed as two centers. Thomas Burnidge came from Massachusetts in 1840, and settled at the intersection of Russell and Muirhead Roads. Soon enough, people lived in the area to start up a Methodist Episcopal Church and cemetery in 1848. The railroad came to town in 1888 (Chicago, Madison, and Northern), and laid its tracks a half-mile south and west of the original village. The post office moved to be near the depot, and soon all the commercial and residential growth went to new Plato Center. The milk production of the entire township was shipped from Plato Center. As did many other villages, towns, and cities in Kane County, Plato Center grew and prospered with the railroads.

Burlington was settled in 1835 by several men, one of whom, Stephen Van Velzer, "claimed all the land in sight, and nearly the entire township." Claim jumping and riots were the order of the day in early Burlington. The first store in town was on the old Galena Road near where Burlington is today, and for a while it was the only store in the township. The Free Will Baptists

congregated in the village in the 1840s, but the first church in town was built by the Congregationalists. A succession of school marms taught in the early schools—Mrs. Catherine Ellithorpe, Miss Nancy Hill, Miss Larrabee, Mrs. Godfrey, and Fanny Putnam. Many of these teachers taught out of their own homes. The Illinois Central Railroad built a branch railroad through Plato and Burlington Townships, which encouraged settlement.

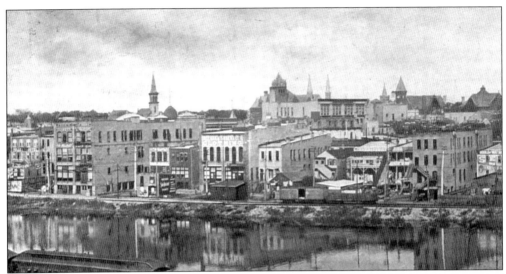

This view of downtown Elgin at the beginning of the 20th century shows a river front full of businesses in transition. By this time, newer brick four-story buildings and factories were replacing earlier two and three-story wooden framed structures. Tracks on both sides of the river enable shipping to reach into the heart of the downtown and also provide commuter service into other parts of the valley.

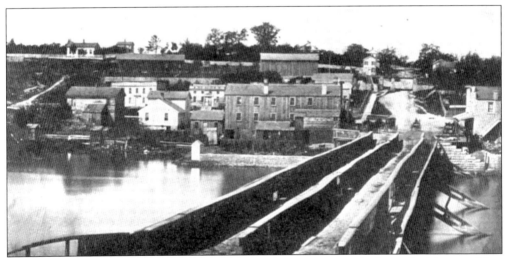

Believe it or not, this was actually a working bridge. Constructed of wood with a partition separating the two lanes of traffic, it appears unsafe, as do the wooden sidewalks hanging from each side. No wonder sudden rains swept away dozens of such bridges up and down the valley in the early years! At the time of this 1866 photograph, there were early mills and homes mixed together at the river's edge in Elgin.

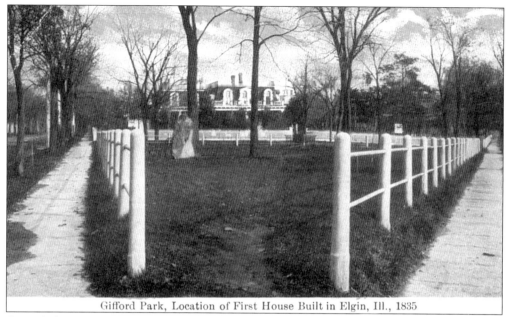

Gifford Park, Location of First House Built in Elgin, Ill., 1835

One of Elgin's most historic sites is located at what is now the corner of Villa and Prairie Streets. It was here that James T. Gifford built the first Elgin log cabin and residence in 1835. This site was later made into a park. Other members of the Gifford family also constructed cabins. Beyond the park is an 1885, 16-room mansion built with stone from New York.

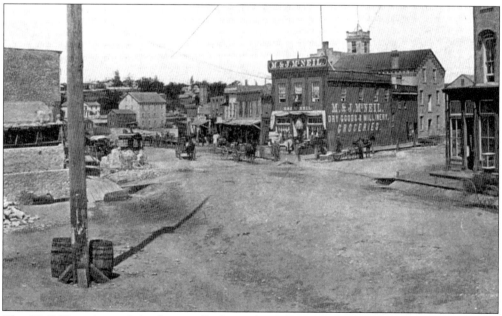

The Civil War triggered the forces of industrialism that soon catapulted towns such as Elgin into cities almost overnight. In this 1866 view, we see the heart of Elgin, looking west from Fountain Square along Chicago Street. The roads are underdeveloped, and when it rained, they must have been mud pits. Notice the gaudy outdoor advertising of M. & J. McNeil's general store.

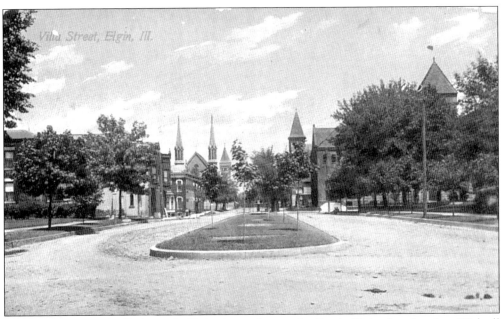

The construction of Villa Street in Elgin shows the touch of early Elgin city planning. With all the style of French boulevards, this wide street with its center green space became a sort of church row for the city. The wide street allowed for carriage traffic on Sundays, and had an overall look of elegance and refinement. The street is not paved, but it has raised curbs to protect the trees, grass, and sidewalks.

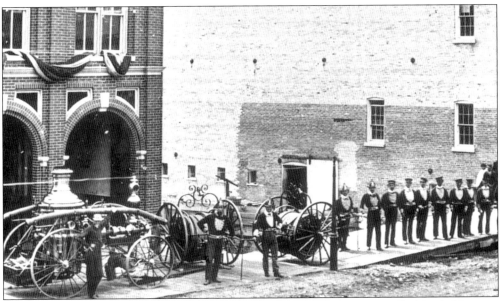

Even though Elgin was becoming more fireproof with the construction of brick-clad homes, businesses, and factories, there were still plenty of wooden structures to keep firemen busy. The colorfully costumed firemen on this postcard are in front of city hall, showing off the city's first James T. Gifford steam pumper fire engine. The bunting on the building suggests that this picture was taken on the day of some patriotic celebration.

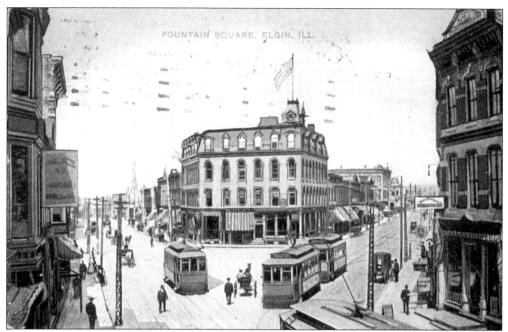

This view of Fountain Square at the height of America's Victorian Age was quite different from the postcard image from 1866. Impressive three and four-story buildings dominate the downtown. Metal poles and telephone lines dot the streets. By 1884, Elgin even had 100 post light towers built and a new power company, the Elgin Incandescent Company, which could generate enough power to illuminate 5,000 lights.

In 1908, Elgin had two modern hospitals, the new four-story St. Joseph Hospital and Sherman Hospital of comparative size. This view is of Sherman Hospital, which was made possible by Henry Sherman and the hardworking members of the Woman's Club. Hospitals of this era were designed to look like large homes rather than commercial buildings.

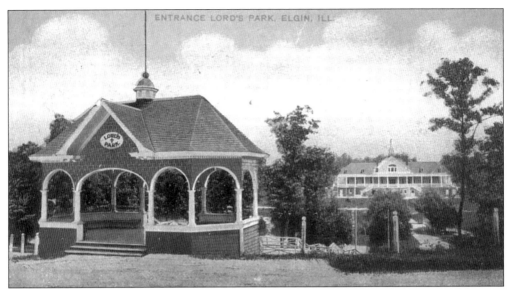

Lord's Park, shown in the card above, was one of the two largest parks in Elgin. Mr. and Mrs. George P. Lord contributed 50 acres of land to establish a park in their name. They also gave enough money to equip the park with such features as a pavilion and a full zoo, which had a lion named Lord Spark. This 1897 postcard shows the park entrance with the pavilion in the distance.

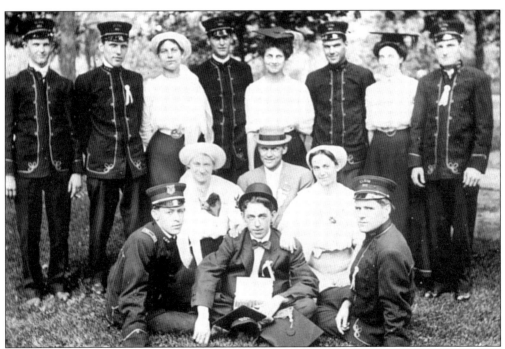

An 1890s high school graduation is a very fitting subject for a postcard! This unidentified group of revelers includes the graduates themselves, with mortarboards and tassels, and members of an Elgin band. Big hats, blouses, and tiny waistlines for women were definitely in fashion when this picture was taken.

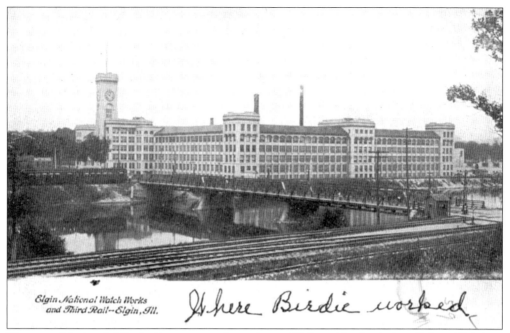

The vast National Watch Factory was brought to Elgin with the help of four Elginites, nicknamed the "Immortals of Elgin." They made sure that the company was given a 35-acre site and that $25,000 worth of National Watch Company stock was bought by the people of Elgin.

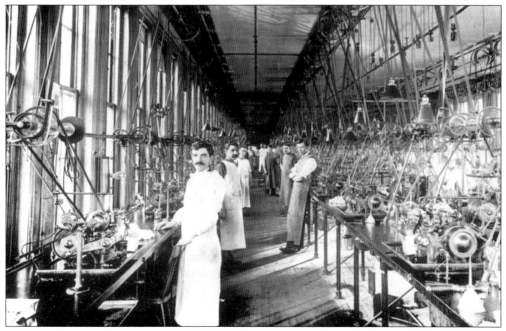

This *c.* 1895 look at the screw department of the watch factory shows the complex nature of watch manufacturing. In order to make Elgin watches, 250 different types and sizes of screws were needed. These were made here. This postcard shows the spider-like leather belting and shafts that connect to a larger shaft, running the length of the room along the ceiling.

The Elgin National Watch Company advertised extensively, using calendars with pretty Victorian beauties and slick ads in *National Geographic* featuring their logo, Father Time. They stepped up their advertising campaigns in the 1920s, and by the time of the New York World's Fair, their display featured a fully operational observatory.

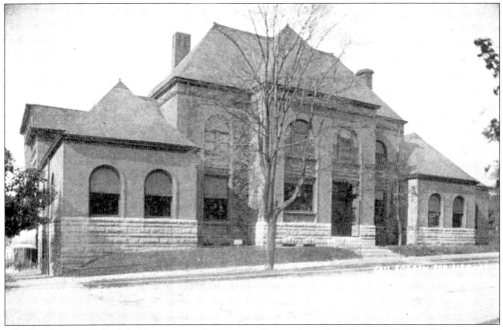

The land on which this library was built was donated to the City of Elgin with only one stipulation—that the library be named the Gail Borden Library. The city spent $9,000 on the building, which first opened its doors in March 1874. Gail Borden invented the process of condensing milk produced in Elgin and elsewhere.

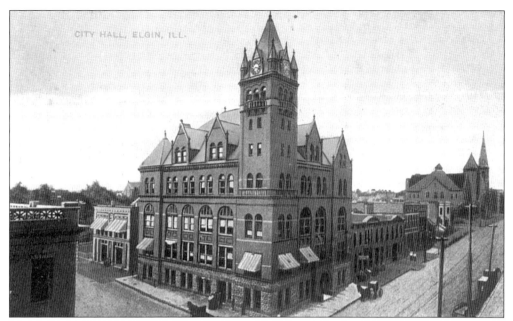

This impressive four-story Romanesque building with a seven-story clock tower was Elgin's fourth city hall. Stone and brick was used, along with arched double windows to give the huge building a more open look. The city hall was completed in 1893, the year of the Chicago's World's Fair.

Who would have guessed that this 1920s swinging group of Elgin musicians were from the Universalist Church? From left to right are: (standing) Dr. Todson, Mrs. Mort Aldrich, Mrs. Moore; (seated) Mrs. George Foote (the band leader), Gertie Jewett, and Madeline Voller. It seems as if the conductor is having trouble with "his" musicians, hence the rifle instead of a baton.

Elgin had one of the first modern retirement homes in the valley. Postcards and brochures stressed the pleasant environment of Resthaven Sanitarium, located in a park-like setting. The home offered two sizes of steam-heated rooms, but each had three windows to make the rooms cheery and bright. Seniors who were lucky enough to afford such accommodations could escape being put into public institutions among the insane.

Elgin also had an insane asylum. It was called the Illinois Northern Hospital for the Insane and was located on the west bank of the Fox River on 480 acres just south of town. It was designed to be a park with gardens in the belief that such a setting would calm the insane and lead to their rapid recovery. The central building was four stories, with men and women living in separate wings and wards. Originally designed for 300 patients, by 1908, there were 460 living there.

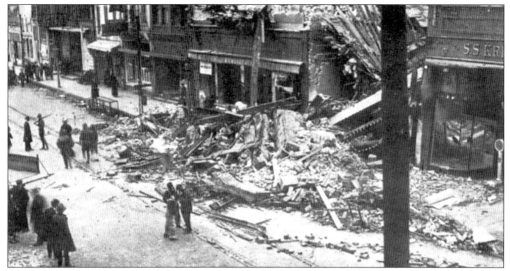

Natural disasters such as snow and wind storms hit each community sooner or later. One of the most devastating to the downtown of Elgin occurred when a tornado ripped through the city on March 28, 1920. In its wake, the tornado left seven dead and widespread destruction, not only in the downtown but also in the residential areas. Postcards of disasters such as this one sold like hot cakes.

This postcard from the early 1930s shows the Robinson's Tire Company of Elgin. The impressive sign on this two-story building touts not only the store but also Firestone Tires. Harvey Firestone was one a group of men whose fortune rested on getting America on the road in cars, wearing out tires, and burning gasoline rather than taking the cheaper, environmentally cleaner and more practical public electric lines by which Kane County was being served.

By the 1930s, Elgin and Aurora had skyscrapers so tall that, on a clear day, people could see Chicago from their roofs. Elgin's skyscraper is more Art Moderne than Aurora's Leland Towers, and it was built as a bank building, not a hotel. It was named the Tower Building. Many postcards were made from images of this building over the years.

Elgin and Aurora have another thing in common—an island in the middle of downtown. Aurora's Stolp Island is large and has buildings on it, but Elgin's Walton Island is small by comparison. This overhead view of the city shows all three bridges that cross the river. Note the rail lines on the west bank of the Fox River and the former building sites being used for parking lots on the east.

Elgin, with its diverse population, was home to over a dozen different churches. Five of the churches even supported missions prior to World War I. The building in this view of the 1903 St. Joseph's German Catholic Church, organized in 1877, was not the first structure for that congregation. This church had seating for about 400 worshippers. A parochial school was built north of the church and was run by the sisters of St. Frances.

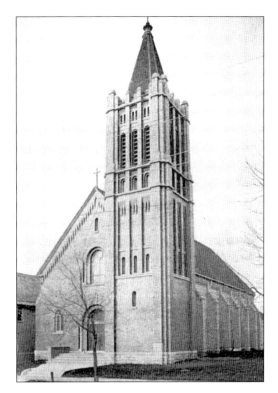

A small band of "liberal people," mostly Unitarians and Universalists, built their first church on Center Street in 1847–48. For many years, the people of that church met in various halls and churches around town. A few years after 1900, the congregation erected this structure at the southeast corner of Villa and DuPage Streets. It was said to have been the best auditorium in the city for concerts.

The first priest to visit Elgin (as a missionary) was a Frenchman, Reverend M. De St. Palais. From this visit in the early 1840s, came the establishment of St. Mary's Catholic Church, which is shown on this postcard. The land for this impressive church was donated by James T. Gifford, and the church building was completed in 1900. One of the first funerals conducted in the church was for the priest who oversaw the start of the building in 1896, Father Mackin.

This 1908 view of the Elgin Episcopal Church captures a typical pre-1900 small Victorian church in all its splendor—covered with vines and with mature trees surrounding the structure. The parish was established in 1858, and it was named Church of the Redeemer. There were 65 communicants in the church under Rector Reverend S.J. French around 1908.

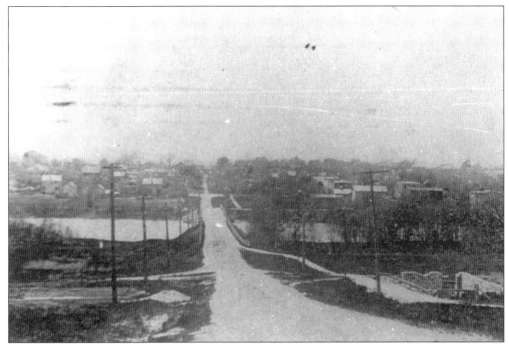

This postcard shows an early view across Bridge Street in South Elgin with one of the village's first wooden bridges. Later on, the street became Main Street with a new, iron-trussed bridge with five piers of "Clintonville stone." There was an amazing amount of stone being quarried in South Elgin's three quarries. By 1891, these quarries were using dynamite to produce 3,600 tons a year!

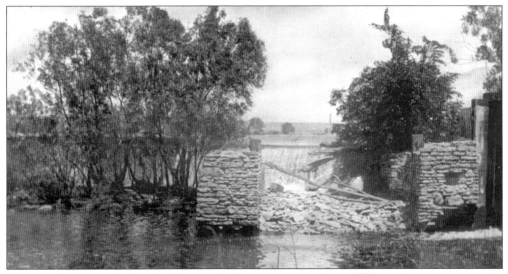

As part of the dam in South Elgin, a lock was constructed in 1887, so that a sternwheeler steamboat could transport stone up and down the river. This manner of transportation for heavy products proved to be a disaster. Using good old Kane County ingenuity, the barge was re-christened the *Dauntless*, and it became an excursion boat for passengers to cruise the river for picnics or moonlit adventures. The dam is shown here, years later, abandoned.

This 1910 postcard of Fred Melin's Tavern has an Eagle Tin beer sign out front. The South Elgin brewery, which made Eagle Tin beer, was located on North State Street next to Giester Brother's Lumber Company. One village president, Trink Panton, accused policemen of "playing cards and shaking dice in the saloons." In 1914, revenue from the three saloons was providing three-quarters of the money needed to run the village of South Elgin!

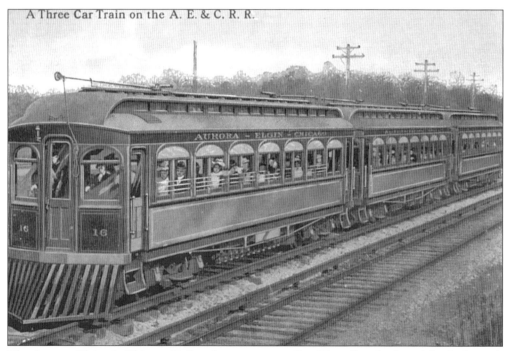

The Aurora, Elgin, & Chicago Railroad was once sending 23 trolleys back and forth through South Elgin on weekdays, from early dawn until late at night. You could board one of these trains and ride to Elgin from South Elgin, 3.7 miles away, for 5¢. This was not the first interurban line into South Elgin, however; in 1896, the village was on the line of a system between Carpentersville and Geneva.

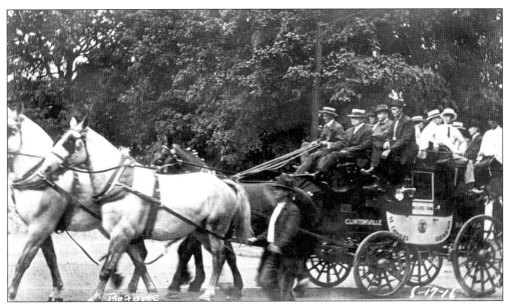

Tally Ho, everyone! We normally think of stagecoaches in association with the Wild West and forget that, for a time, Kane County was the west! This card shows coach service from Geneva—St. Charles to Clintonville—South Elgin's early name. Notice the names of all three villages on the side of the coach.

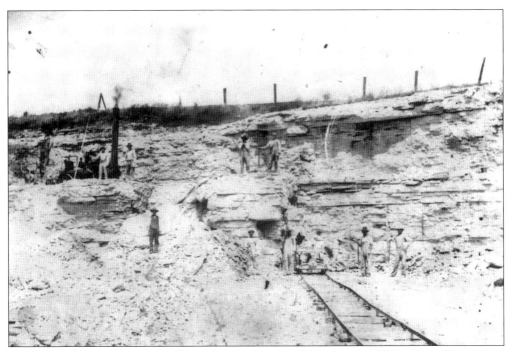

The demand for limestone was high after the fires in Chicago in the 1870s. Kane County had many sites along the river where limestone was quarried, and some of the best came from South Elgin. This view of one of South Elgin's quarries shows mining equipment on a bluff to the left and the rail tracks and loading car used for moving stone to shipping containers.

Charles Rosene's gas station is shown above as it was in 1933, with Charlie out front. The building was originally a chicken house that was made into a small house. Mr. Rosene purchased the property and had the house moved to this location. Ted Larson later installed two windows.

There were over 200 car manufacturers in the United States by the 1920s, building cars in a frantic effort to keep up with customer demand. City slicker and farmer alike took to the roads, and they demanded paved roadways and the new businesses of roadside gasoline stations. You could stop and get a fill-up of Cities Service gasoline at Rosene's station in South Elgin. You could also see the gasoline go thorough the glass tower over the pump as it went into your tank. Other new businesses were roadside motels, fast food restaurants, and drive-in movies.

Later gas stations run by big oil companies all began to look alike, with special colors and sleek streamlining for easy identification by the motorist. Each grade of gasoline had its own special unique name, and stations had large lighted signs to further attract attention during the night. Cities Service and other major companies began to promote that they sold not only gas, oil, and other car needs, but that they would also service your car as well.

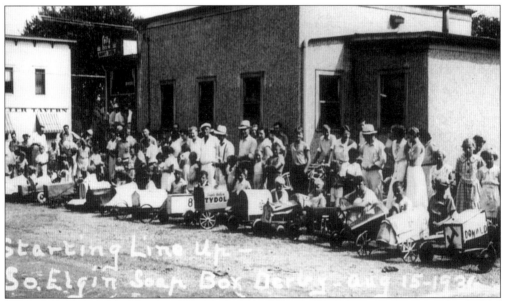

Here is a view of a Soap Box Derby held in South Elgin on August 15, 1931. Behind the drivers and spectators to the left is the Schiebel Tavern. This tavern was built on a foundation that was used for Henry Hopp's Grocery Store during the early 1900s. That store burned in 1926. The Reinert family built the stucco building on the right, which was used as a grocery store and ice cream parlor.

Judge Kostrup's cobblestone house at 180 North Main Street was built by a former New Yorker, John Peaslee, who built several of these houses in South Elgin. The house is reported to have been built in 1835, and it is now the home of the South Elgin Heritage Commission. Cobblestones were favored by builders in western New York because of their durability and colors, a preference they took west with them.

This is the Cox house, built in 1852 for $1,401. The Lloyd family later purchased this house at 265 South Gilbert Street, and several generations of Lloyds have lived here. The two boys on the fence in this autumn view are doing what boys of that era liked to do often if they had the chance—nothing!

Plato Center, which developed along the railroad, had eight frame buildings and two streets in 1892. Chicago Street and Rippburger intersected at the train depot. Houses were spread out in the countryside all around the depot, one of which is shown in this view. The first store in the township was built in Plato Corners in 1848.

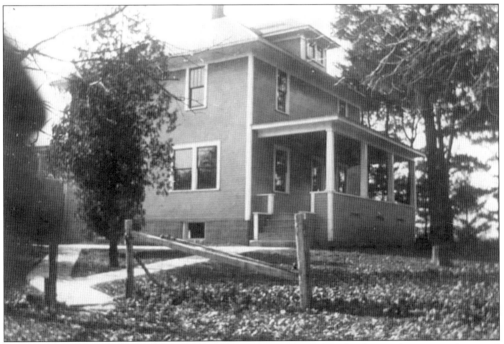

As farmers in and around Plato Center began to prosper, they built new houses and moved into town. This view is of a house in Plato Center simply titled "new house." It was probably erected about the same time that Arthur M. Haines, former farmer, became the manager of the local creamery.

The Illinois Central Company built a branch railroad through Burlington and encouraged local shippers to use the line to take their produce to market. Milk and cheese were produced in and around Burlington during the 1870s, with three cheese factories using the local milk. This postcard shows a railroad track and an old railroad storage building alongside the track in downtown Burlington.

Also in downtown Burlington about the same time was a butter factory, located on Water Street. This view is of a *c.* 1890 downtown building, which is still standing and in commercial use. Notice the low profile bricks used in the building and the stone sills and lintels. The iron post at the corner of the building helps to support the large, ornate, four-windowed turret.

Seven
Dundee, Carpentersville, Hampshire, Starks, Gilberts, Pingree Grove

Dundee was settled in 1834, by Joseph Russell and J.H. Newman, who built cabins on opposite sides of the Fox River and constructed a dam and a sawmill. Dundee developed as East-West rival settlements. The largest business in town by the 1870s was the Dundee Brick Company, which sold about 3 million bricks a year. The clay used to make the cream-colored bricks came from the high bluffs on the east side of the river. The land around Dundee in the 1800s, and into the next century, was good for grazing of animals, and this part of the county had many springs of almost pure water. Mormons were the first to settle between Dundee and Carpentersville. They built a church, but as an early author noted, "The sect did not last long." Because of the excellent land, the Borden Condensed Milk Company located a factory in the township. In the 1870s, Sidney Wanzer and Jesse Oatman also had dairies in the area.

Carpentersville is 1 mile north of Dundee on the Fox River. It was first settled by Daniel G. and Charles V. Carpenter in 1837. The Carpenters ran the village and built the first bridge at their own expense in 1851. A school building was built in 1855, with a Sons of Temperance Order using the second floor. As in many other Kane County communities, followers of the Congregational Church seemed to be first on the scene. A dam was built in 1837 by the Oatmans of Dundee, so that water could be diverted down the west side for Dundee. J.A. Carpenter, not wishing to lose power for his factories in his town, soon had all the power of the river in his hands exclusively. Carpenter built his Valley Woolen Mills in 1866, and he was co-owner of the Illinois Iron and Bolt Company by 1868. This last company, along with Star Manufacturing, would become Dundee Township's largest employers. Carpentersville had a reading room in 1881, where one could go to read, but not check out, books. The town had its first real library, where books could be lent to the town residents, in 1897.

Hampshire was originally called Old Hampshire when settlers began to arrive in the late 1830s, since several of the early pioneers were from New Hampshire. Samuel Rowell arrived in 1834 from Kentucky and opened a store in 1850. The new town of Hampshire was created in 1874. That same year, the Chicagoland Pacific Railroad ran a line through the village. The township donated $26,400, so that the railroad would locate at Hampshire. This new village had also been called Hampshire Center, and Henpeck was yet another name for the community when it served the wagoneers driving over the old plank road to Galena. The entire village had to relocate in order to have the railroad. The first train steamed into Hampshire in May of 1875. The railroad brought business to the village, and by the 1870s, the village had four general stores, dress shops, a wagon shop, a hardware store, a drug store, a farmer goods store, a hotel, a saloon, two halls used for theatrical entertainments, lumber yards, a blacksmith shop, a cheese factory and a grist mill. In 1881, Hampshire was the second largest milk shipping station in the state, 400 cans, all destined for Chicago.

Starks was named after E.R. Starks, who arrived in Kane County in 1835. He came from Rutland, Vermont, thus providing the township with is name—Rutland. Starks and a friend, Elijah Rich, built and shared the first log cabin the township in 1836.

Gilberts was first called Gilbert Station. It was laid out and platted by Andrew Pingree and Elijah Wilcox in 1855. At that time, John Kelly was the acting express agent and postmaster. Later on he would be the county sheriff. Gilberts was at one time the home of Haeger Pottery, and in 1882, it had the largest brick and tile factory in Illinois. It was incorporated as Gilberts in 1890.

Pingree Grove was named after Straw, Frances, Andrew, and Daniel Pingree, who first came to Rutland Township in the late 1830s, staked out claimed, left, and returned in 1844. The area was quite a wilderness in 1838. There were only three small log huts between Pingree Grove and Elgin. This small village got a post office in 1848, with Andrew Pingree acting as its first postmaster. The struggling Chicago and Pacific Railroad was being built in 1874, and was strapped for money to complete the line west. When they reached the lands of Andrew and Doctor Daniel Pingree, the brothers not only gave them the right of way for free, but they also gave the railroad $15,000 and built the depot. By 1877, milk worth $4,085.80 and other goods worth $833.35 were shipped from the station.

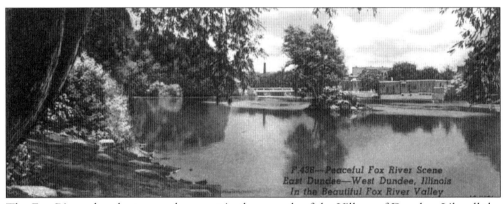

The Fox River played a tremendous part in the growth of the Village of Dundee. Like all the towns along the river, water power was first used to power the machinery of industry. The first settlers also found limestone, clay, rock, and sand deposits necessary to build the taller buildings in cities such as Chicago, where the only way to build after the Civil War was up.

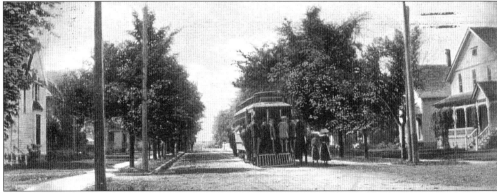

Dundee was served by trolleys beginning around 1900, just as were the other Fox Valley towns. This card shows a trolley going down Second Street in Dundee, which was a quiet, residential part of town. At first, trolleys were drawn by animals on tracks, but soon they were powered by overhead electrical lines and in rural areas by an electrified third rail.

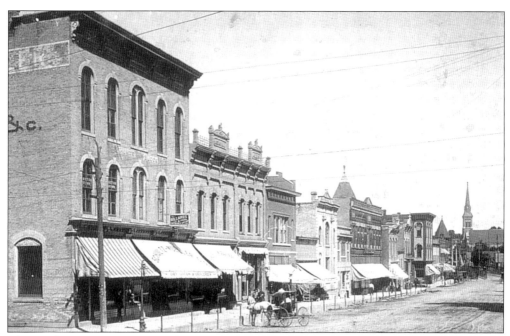

This is downtown West Dundee around 1910, showing the north side of Main Street at Second Street looking east. The building on the left is a modern three-story brick structure that housed a dry goods and grocery store downstairs and a billiards parlor on the second floor. The wide street is unpaved with only a horse and buggy in near sight. The old Immanuel [sic] Lutheran Church in East Dundee can be seen in the distance.

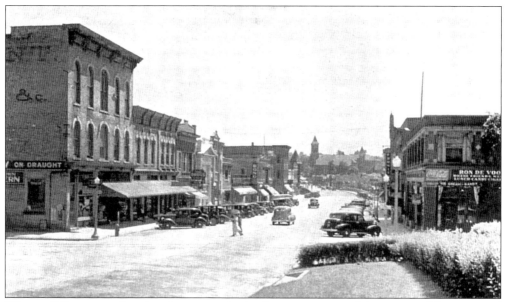

What a difference a few decades can make in the appearance of downtown. This postcard shows the same street with the same building to the left in the 1930s. The road is developed, and the town has installed street lights. Most of the buildings that were around in 1910 are still in commercial use. Not a buggy in sight, though!

This postcard shows the same street, still in the late 1930s, looking west. An older building has been torn down on the north side of the street and replaced by a sleek, Art Moderne movie theater called The Dundee. There is a half-century age difference between the theater and the three-story commercial building to its left.

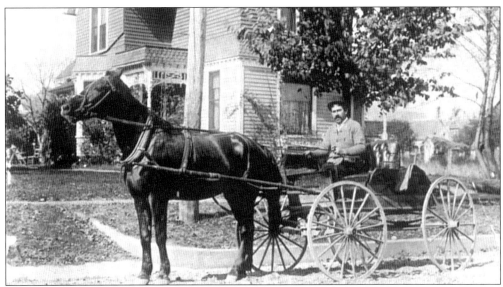

Prior to the use of gasoline trucks, commercial goods were moved by teamsters who handled four to six horse rigs to deliver items such as beer barrels and wooden crates from their point of manufacture to customers. Even when the railroads were used for long distance to haul freight, carts and wagons were necessary for local deliveries. It is no wonder that the combined production of buggy and wagon factories in Kane County numbered in the thousands.

The heavy manufactures up and down the valley had thousands of hard working, blue-collar workers who were more than ready, especially on pay day, to stop by their favorite saloon before going home to the wife and kids. Social reformers of the 1890s fought the evil of "demon rum" to no avail. This little poem postcard describes the controversy between those who wanted a wet and those who wanted a dry town.

*THEY say some towns are rather "dry"
While other towns are "wet",
But any town that has us "beat"
Has not been heard from yet.*

This idyllic scene along the Fox River in Dundee misleads us to think that, in the "Good Old Days" a hundred years ago, our rivers and streams in Kane County were clean and unaltered by man. In fact, with the first dams and mill races, the character of the Fox River was dramatically changing even then.

The new Victorian middle class of the last two decades of the 19th century built large, multi-roomed mansions as a way to show their new class. Many homes had a greenhouse attached to the house and extensively landscaped grounds. From whom in Chicagoland could you order your trees, shrubbery, and bushes in 1911? The answer was David Hill's Nursery in Dundee, Illinois. Postal and freight rates were cheap. Not only did the Hills use thousands of these postcards to acknowledge orders, but they also issued mail order catalogs from time to time. Such merchandising of nursery goods occurred at the same time that other mail order companies such as Sears Roebuck and Montgomery Ward were becoming direct retailing giants.

Hill's Nursery would use the back of this card to acknowledge the order, and they stamped the date and order number on it. There was a place to put in remittance received or due as well as to tell the customer whether the merchandise was being shipped by freight, express, or mail.

This nostalgic card resembles a tranquil Currier and Ives print with people down by the river enjoying themselves—man and nature in perfect harmony. Contrast this with the postcards from Kane County that show crowded manufacturing along the river.

Carpentersville was much more of an early industrial town than Dundee. However, this postcard of an 1875 scene shows the area below the dam as a marshland, with river tributaries reaching out to fertile farmlands with fenced pastures for animals. In 1908, there were 100 to 160 acres of a thick peat east of Carpentersville. The peat was said to be 6 feet deep in some places. Some envisioned this as being a potential fuel.

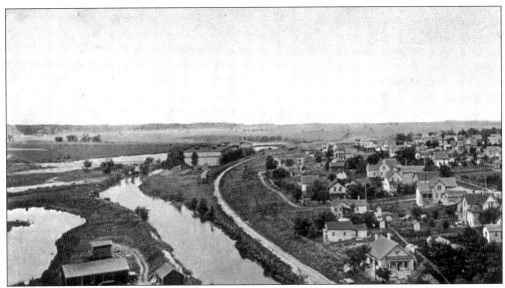

This bird's-eye postcard of Carpentersville shows the prosperous new, middle-class homes being built in the town and a mill on the peninsula across the river. From all appearances on this card, the entire town rested in a deep, swamp-like valley.

Yet in this view of the town, it is evident that Carpentersville was also on rolling hills. Notice the tip of the industrial core located on the river below the dam in the background and over the trees. The chimneys of the Illinois Iron and Bolt Company and the Star Company can be seen in the distance.

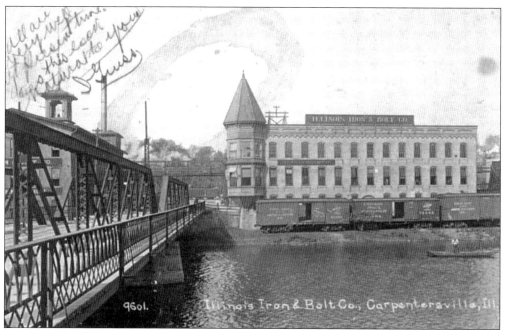

The Illinois Iron and Bolt Company was located on the banks of the Fox River beside the impressive new iron bridge in this postcard. This company was making bolts by 1868, and they also manufactured thimble skeins, sad irons, pumps, copying presses, seat springs, and lawn vases. This view is from the turn of the century.

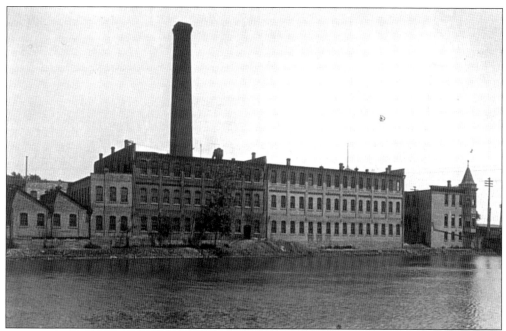

This view is of the street side of the building on the previous card. Most of these downtown former factory buildings are still in existence awaiting careful restoration. The Illinois Condensing Company was also on the west bank of the river.

The Illinois Iron and Bolt Company had buildings on both sides of the street. This 1875 view is of the south building, as seen from the south. Notice that there was still vacant land south of the Illinois Iron and Bolt Company's buildings in 1875.

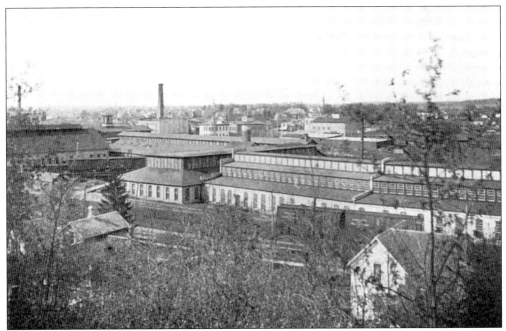

This bird's-eye view shows the Star Manufacturing shops in the foreground, with the Illinois Iron and Bolt Company in the background across the river. Wide mill races were needed on each side of the dam to keep these large manufacturers supplied with power.

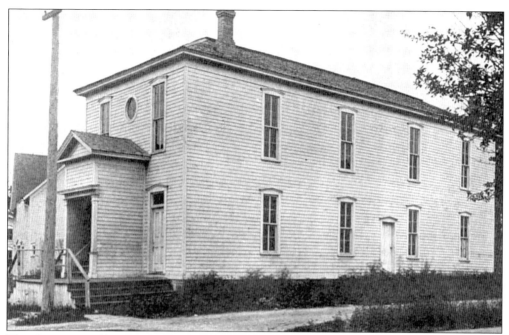

The Carpentersville Literary and Library Association was formed in 1871, under the political influence of Julius Angelo Carpenter, a member of the state legislature. A building no longer used by the district school, but jointly owned by a temperance group called Hand in Hand Division, Sons of Temperance No. 292 was shared for a time as a library, with financial support from Mrs. Carpenter and Mrs. Mary E.C. Lord.

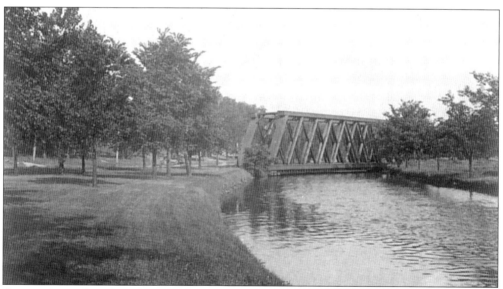

Companies such as those located in Carpentersville grew and prospered in the post-Civil War period. Not only did railroads need locomotives and iron tracks, they also needed to construct strong bridges across the rivers. Only recently have preservationists come to appreciate such powerful and yet graceful bridges as this one located in Carpentersville as works of architectural art.

This library was dedicated in 1897, as a gift from Mrs. Lord to the readers of her community. When Mrs. Lord died in 1905, an endowment fund was set up to maintain the building and its collection. This 1897 structure is as pretty as a wedding cake, with its beautiful stained glass windows.

The library was located on a street lined with opulent Victorian two and three-story houses. Such impressive houses attest to the fact that industrialism did not simply produce rich and poor people, but it created an entirely new class called the middle class. The churches of the day touted that the virtue of hard work would produce such success.

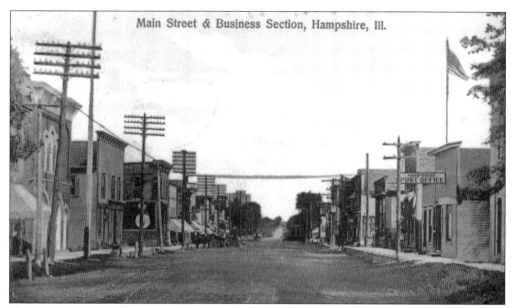

This 20th century postcard shows Main Street in the business section of Hampshire. The town's motto is "Where Town and Country Meet." Old Hampshire to the north, located around the vicinity of Route 20 and Big Timber Road, offered travelers lodging and liquor on their way west. It is said that in the 1880s, 50 to 100 wagons a day passed through Hampshire.

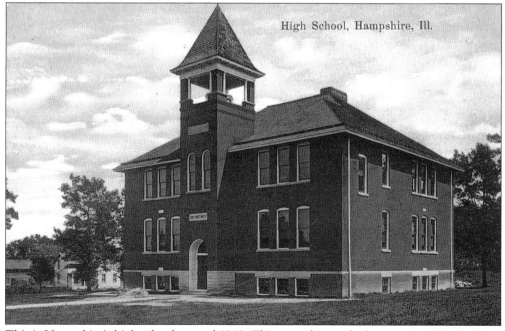

This is Hampshire's high school around 1900. This township made the news in 1943, by being the first in the state of Illinois to pass a tax levy without a single dissenting vote. Hampshire's first high school was built in 1876, at a cost of $3,500. One of the town's most unusual factories was a wind and steam machine with flying arms, invented by William Rinn in 1875.

This view shows a St. Charles Day Parade around the time of World War I, with a cadre of nuns from the Rutland Township Catholic Church. In 1855, Andrew Pingree gave the land for the church, which was located about 2 miles west of Gilberts.

The first school house in the township was a log cabin built in 1840, but by 1855, there were 11 school districts in the county with 619 students. By the time that the village was platted and laid out by Daniel and Hannah Pingree in 1882, the village had about 550 residents. This 1892 public school was located on the main street in Pingree Grove, State Road. This view was taken in December 1935.

When E.R. Starks arrived in Rutland Township, there were still a few Native Americans around. He left his claim in 1835 to go to Naperville, and he returned the next year with Elijah Rich, who staked a claim next to him and shared a log cabin with him. Several other settlers came to the area in the next year. Earlier taverns and boarding houses on the Kane County frontier were nothing more than cabins that the owners shared with travelers.

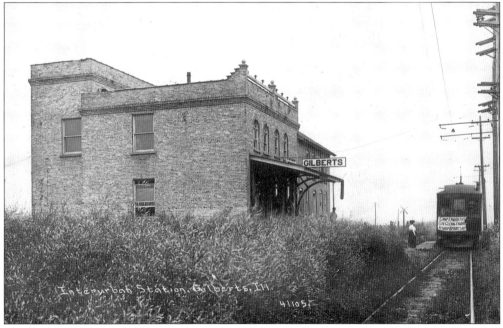

Besides being knows as Gilberts Station, the village of Gilberts was also called Rutland in 1852, when a post office was located there. This historic postcard shows the last electric interurban to pass through the railroad station at Gilberts. Look at the sign on the front of the trolley signifying the end of an era, as this postcard is the end of *Kane County in Vintage Postcards*!

INDEX

Aldrich, Mrs. Mort 97
Alexander, Julius 58
Ament, Colin 46
Anderson, Emma 60
Anderson, Ida 60
Anderson's Green Houses 53
Appleton Company 54
Arcada Theatre 76, 86
Aurora 15, 16, 21, 22, 24–36, 38–44, 49, 62, 80, 100
Aurora Brewing Company 57
Aurora Daily Beacon News 16
Aurora HistoricalSociety 6
Aurora Hotel 34
Aurora Opera House 27, 29
Aurora Theater 27
Aurora, Elgin, and Chicago Railroad 104
Aurora, Illinois 41
B Theater 29
Baker family 19
Baker Hotel 72, 76, 86
Balduc family 19
Ballantine Distillery 89
Bancroft, Horace 79
Baptist Church (Wasco) 87
Barker, _____ 68
Batavia 15, 16, 18, 24, 49–52, 54–57, 72
Batavia High School 52
Bean, Simeon 69
Beasley, Harwood 58
Behn, Joe 6
Belle Jardinieve 14
Bellevue 55
Benjamin, Robert 69
Bergland, George 87
Big Rock 19, 25, 45, 47
Big Rock High School 46
Big Rock Historical Society 6
Big Rock Plowing Match 6
Blackberry Station 69
Blackberry Post Office 69
Blackhawk 15
Bliss, P.Y. 20, 47
Borden Condensed Milk Co. 89, 111
Brady and Pease Clothing Emporium 27
Bringham, Mildred 46
Brown, Julius 65
Brownell & Miller Paper Mill 69
Brush Electric Light and Power Company 42
Burchell, P.J. 77

Burlington 89, 90, 110
Burnidge, Thomas 89
Butcher, Gladys 6
C.R. Childs Company 12
Cable Piano Company 79, 80
Campana Company 55
Canada Corners 69
Carnegie, Andrew 38, 78
Carpenter, Charles V. 111
Carpenter, Daniel G. 111
Carpenter, Julius Angelo 111, 121
Carpenter, Mrs. 122
Carpentersville 104, 111, 117, 118, 121
Carpentersville Literary and Library Association 122
Central States Fair and Exposition 66
Challenge Company 54
Charleston 69
Chicago 20, 28, 33, 49, 70, 105, 112
Chicago & Northwestern Railroad 70
Chicago Symphony Orchestra 29
Chicago, Aurora & Elgin Electric Railroad 21, 30
Chicago, Burlington & Quincy Railroad 25, 31, 35, 36, 50
Chicago, Madison, and Northern Railroad 89
Chicago, St. Paul and Kansas City Railroad 83
Chicago and Pacific Railroad 112
Christopher Payne 49
Church of the Redeemer 102
Clark, Rev. John 47
Claude, _____ 46
Clintonville 89, 105
Colby, Guy 68
Collins, Dr. Nathan 89
Colored Methodist Episcopal Church 49
Colson's Department Store 71, 72, 75
Congregational Church (Lily Lake) 83
Congregational United Church of Christ (Big Rock) 25
Corron, Joseph P. 89
Cox family 108
Crown Electric Manufacturing Company 80
Curt Teich Company 12

D.C. Cook Publishing Company 89
David Hill's Nursery 116
Davis, Bessie 46
Davis, Harold 46
Detroit Publishing Company 12
Dixon 50
Dixon Air Line 50
Downs, Donald 41
Dreamland 27
Dundee 16, 111, 112, 115, 116
Dundee Brick Company 111
Dundee Township Historical Society 6
Dunham Castle 86
Dunham Woods Riding Club 86
Dunham, Mark 86
Dunham, Solomon 86
Duszlak, Len 6
E.C. Kropp Company 12
Eagle Mills 26
East Aurora High School 41
East Dundee 113
Elburn 69, 84
Elburn Meat Market 84
Elgin 15, 18, 21, 62, 70, 89–99, 101, 102, 111
Elgin Academy 22
Elgin Advocate 89
Elgin Area Historical Society 6
Elgin Daily Courier 89
Elgin Daily News 89
Elgin Incandescent Company 93
Elgin Silver Plate Company 89
Elk's Lodge 705 39
Ellithorpe, Mrs. Catherine 90
English Congregational United Church of Christ (Big Rock) 26
Evan's Grand Opera House 27
Evans, Colonel Henry H. 29
Evans, Fannie 6
Evans, Levi 6
Evans, Merritt 6
Evans, Nell 6
Evans, Tillie 6
F.E. Royston & Company 31
Fabyan, Colonel George 50, 59, 60
FermiLab 15
Ferson, Dean 69
First American Bank 29
First Baptist Chruch (Big Rock) 25
Fitchie family 19
Foote, Mrs. George 97
Fox River Park 44

126

Fox River Advocate	16	Hudson, J.B.	40	Lord, Mrs. George P.	94, 122
Fox Theater	27	Huss, Michael	85	Lord, Mrs. Mary E.C.	121
Fox Valley Blue Print	32	Illinois Centennial Memorial Arch 71		Lords and Fouteers Company	51
Fred Melin's Tavern	104	Illinois Central Railroad Company 90, 110		Louis Klink's Wagon and Carriage Shop	69
Free Will Baptists (Burlington)	89	Illinois Condensing Company	119	Louisville, KY	49
Frelsen, Otto	81	Illinois Industrial School for Girls	57	Loyal Order of the Moose	61
French, Reverend S.J.	102	Illinois Iron and Bolt Company	111, 118–20	Luckett, William and Harriet	81
G.A.R.	26, 32	Illinois Northern Hospital for the Insane	98	Lyric Theater	27
Gail Borden Library	96	Illinois, Iowa, and Minnesota Railroad	48	M. & J. McNeil's General Store	91
Galena	49	Immanuel Lutheran Church	113	Mackin, Father	102
Galena & Chicago U.R. Railroad 89		Immortals of Elgin	95	Majestic Theater	27
Galena and Chicago Union Railroad	50	Inland Development Company	34	Maple Park	26, 70, 88
Gammon, Elijah	4	Jack and Norm's Shoes and Men's Toggery Store	72	Maple Park Town Hall	88
Garner, Joanna	81	Jackson, Andrew	15	Markel, Mrs. Celia Ida	69
Garton, Elijah	69	James, John	45	Marshall, Thomas R.	61
Gefft, Dr. Joseph	89	James, Polly	46	Marshall's Grocery	32
Geneva	23, 49, 57, 70, 104, 105	James, Wyle	46	Mathes, ___	35
Geneva History Center	6	Jennings Seminary	41	Mc Kinley's funeral	40
Geneva Republican	48	Jewett, Gertie	97	McCarty brothers	15
German American Bank	29	Jones, Arlic	45	McCarty, Joseph	25
Giester Brother's Lumber Company 104		Jones, Gladys	46	McHenry County	23
Gifford, James T.	89, 91, 92	Jones, Otis	49	Meek's Mill	69
Gifford, Hezekiah	89	Jones, Orva	6	Merra-Lee Shop	61
Gilbert, Truman	89	Joslyn, Frank W.	15, 19	Methodist Episcopal Church (Batavia)	4
Gilberts	112, 125	Joslyn, R. Waite	2, 6, 15, 19	Methodist Episcopal Church (Plato Center)	89
Girl's State Industrial School	49	Joyce, Donald	58	Miller, Alva	46
Godfrey, Mrs.	89	Joyce, Tom	58	Miller, Laurence	46
Goote, Mrs. George	97	Kane County 1936 Board of Supervisors	24	Miller, Rachael	46
Grace Methodist Church	88	Kane, Elias	50	Milwaukee	23
Gray & Watkins	43	Kaneville	50, 67, 68	Montgomery	25, 43, 44
Gray, Daniel	25	Keefe, Preston	70	Montgomery Ward	116
Gregorek, Ron	6	Kellogg, Lottie	41	Moore, Mrs.	97
Gum, Ruth	46	Kelly, John	112	Moosehaven, FL	61
H. Ziegler Dietz	34	Kendall, William	69	Mooseheart	24, 49, 61–64
Haeger Pottery	111	Kinny, ___	46	Morris, D.J.	45
Haight, Daniel S.	49	Kirk, B	58	Morris, Staley	45
Haines, Arthur M.	109	Knight, William	77	Morrison Company	12
Haley, Clara	6	Kobiyashi, ___	60	Morse, J.	26
Halladay, Daniel	54	Kostrup, Judge	108	Motylinski, Shari and Paul	6
Hamilton, R.J.	49	Lecos, ___	35	Mucha, Alphonse	14
Hampshire		La Fox	50	Naperville	125
Hampshire High School	124	Lake, Theodore	25	National Watch Company 89, 59, 96	
Hand in Hand Divison, Sons of Temperance No. 292	122	Lanterman, Anna	45	New Virgil	85
Hardy, Ralph H.	67	Larrabee, Miss	90	Newman, J.H.	111
Harvey, Mrs. Julia Plato	57	Larson, Ted	106	Newton, Mrs. Don Carlos	56
Henry Hopp's Grocery Store	107	Laughlin, John	69	Newton, Captain Don Carlos	4, 56
Henry Rockwell BakerMemorial Community Center	77	*Le Journal*	40	Newton, Earl Cooley	56
Herrington, James	49	Leland Towers	28, 42, 100	Newton, Levi	56
Hess, Dale	6	Lily Lake	69	North Aurora	49, 65, 66
Hill, L.O.	42	Lincoln, Abraham	55	North Aurora Manufacturing Company	65
Hill, Miss Nancy	89	Lincoln, Mary Todd	55	North Aurora Mill Co.	65
Holter, Norves	35	Lindsey, Alden	46	North Aurora Sash, Door, and Blind 65	
Hopkins, A.J.	37	Lipp, H.E.	40	Northwestern Railroad	49
Hord, Brodhead & Company	43	Lloyd family	108	Oatman, Jesse	111
Hotel Arthur	30	Lodi	70	Old Second National Bank	6
Hotel Baker	82	Lord Spark	94	Overgard, Terrance	46
Hotel Geneva	61	Lord, George P.	94	Palace Theater	27
Howard, David	77				
Howard, Frances Christmas	69				

Paramount Theater	27
Parish, Grace	46
Patterson, Dr. R.C.	55
Paul R. Vogel	26
Paulis, N. S.	31
Payne, Christopher	15, 49
Pease, John H.	42
Peaslee, John	108
Peterson Company	26
Philadelphia Moose Lodge No. 54 63	
Pierce, Elijah	25
Pingree Grove	112, 124
Pingree, Andrew	112, 124
Pingree, Hannah	125
Pingree, Dr. Daniel	112, 114
Pingree, Frances	112
Pingree, Straw	112
Plato Center	89, 109
Plato Township	16
Plummer Company	12
Pottawattomie Park	73
Potter, Lemuel	50, 68
Powell, Maude	29
Princess Theater	27
Putnam, Fanny	90
Quincy	31
Rainbow Room	82
Raphael Tuck & Sons	26
Rasmussen, ____	59
Raymond, Roy	46
Read, Welford A.	69
Reinert family	107
Resthaven Sanitarium	98
Rhodes, Joshua	25, 45
Rialto Theater	30
Rice, Eloise	6
Rich, Elijah	112, 125
Richards, Irene	46
Rinn, William	123
River View Park	44
Robinson's Tire Company	99
Rosene, Charles	106
Rowell, Samuel	111
Russell, Joseph	111
Rounseville, Rev.	16
Rutland Township Catholic Church 124	
S.L. Bignall Hardware Company	69
Saturday Evening Post	58
Schiebel Tavern	107
Schneider, John F.	65
Schneider, John Peter	49
Schultz, Linda	6
Schultz, Norman	58
Scott, J.H.	67
Sears Robuck and Co	116
Seidel, Emery	35
Shelton, Quincy	69
Shepard, Joseph	50
Sherman Hospital	93
Sherman, Henry	93
Shirley, W.E.	41
Shoop, J.	25
Sisters of St. Dominic	78
Skarin, Art	58
Skarin, Gilbert	58
Slater, Thomas	25
Smith, ____	35
Smith, Richard I.	65
Sousa, John Philip	29
South Elgin	89, 103–108
South Elgin Heritage Commission 6, 108	
St. Charles	17, 18, 69–80, 83, 86, 105
St. Charles Dairymen's Association	69
St. Charles History Center	6
St. Charles Hotel	77
St. Charles Municipal Building	86
St. Charles National Bank	72
St. Charles Patriot	16, 69
St. Joseph Hospital	93
St. Joseph's German Catholic Church	101
St. Mary's Academy	78
St. Mary's Catholic Church	102
St. Palais, Reverend M. De	102
Star Manufacturing	111, 118, 120
Star Theatre	27
Starks	111
Starks, E.R.	111, 125
Statlander, ____	35
Stolp, J.D.	26
Stolp, J.G.	38
Stone brothers	65
Stuart, Margaret	46
Sugar Grove	18, 20, 25, 47
Sugar Grove "Normal & Industrial" School	48
Sugar Grove Historical Society	47
Sugar Grove Methodist Church	47
Sunfeaf, ____	58
Supreme Lodge of the World, Loyal Order of the Moose 49, 62	
Sylvandell Entertainment Palace	30
Teich and Company	26
Terminal Station	30
The Art Institute of Chicago	14, 81
The Dundee Theater	114
Theaodore Thomas Orchestra	29
Thomas Dunham Co.	26
Thomas, Gordon	46
Thor Company	26
Tiffany, I.	65
Todson, Dr.	97
Tower Building	100
Troxel	26, 48
U.S. Wind Engine & Pump Company	50, 54
Union Congregational Church	49
Unitarian Society	49
United States Post Office	47
Universalist Church	97
Valley Woolen Mills	111
Van Nortwick, John	51, 52
Van Velzer, Stephen	89
Virgil	19, 69, 85
Voller, Madeline	97
Walker, Eldridge	69
Wanzer, Sidney	111
Ward, Calvin	79
Wasco	70, 87
Waverley Cycle	14
Wayne	69, 70, 86
Wayne Station	69
Wendt, Jack	6
West Aurora High School	41
West Dundee	113
Western Wheeled Scraper Works	37
Whildin, Leslie	45
Whildin, Merritt	45
Whiddon, E.	46
Wilcox, Elijah	111
Williams, Della	6
Willigam, Dwight	46
Wilson, Dr. Jacob Henry	49
Wilson, Judge	49
W.L.S.	68
Wold, Sexton & Truex	77
Women of the Mooseheart Legion 64	
Wood, Charlotte	6
Worsley, Timothy	61
Yorkville	70
Ziegler, Henry	70
Zimmerman, Saxe and Zimmerman 39	
Zouaves	40